Comments on other *Amazing Stories* from readers & reviewers

"*Tightly written volumes filled with lots of wit and humour about famous and infamous Canadians.*"
Eric Shackleton, *The Globe and Mail*

"*The heightened sense of drama and intrigue, combined with a good dose of human interest is what sets* Amazing Stories *apart.*"
Pamela Klaffke, *Calgary Herald*

"*This is popular history as it should be... For this price, buy two and give one to a friend.*"
Terry Cook, a reader from Ottawa, on **Rebel Women**

"*Glasner creates the moment of the explosion itself in graphic detail...she builds detail upon gruesome detail to create a convincingly authentic picture.*"
Peggy McKinnon, *The Sunday Herald*, on **The Halifax Explosion**

"*It was wonderful...I found I could not put it down. I was sorry when it was completed.*"
Dorothy F. from Manitoba on **Marie-Anne Lagimodière**

"*Stories are rich in description, and bristle with a clever, stylish realness.*"
Mark Weber, *Central Alberta Advisor*, on **Ghost Town Stories II**

"*A compelling read. Bertin...has selected only the most intriguing tales, which she narrates with a wealth of detail.*"
Joyce Glasner, *New Brunswick Reader*, on **Strange Events**

"*The resulting book is one readers will want to share with all the women in their lives.*"
Lynn Martel, *Rocky Mountain Outlook*, on **Women Explorers**

REBEL WOMEN OF THE EAST COAST

REBEL WOMEN OF THE EAST COAST

Daring to Go Beyond the Limits

HISTORY/BIOGRAPHY

by Michelle Porter

PUBLISHED BY ALTITUDE PUBLISHING CANADA LTD.
1500 Railway Avenue, Canmore, Alberta T1W 1P6
www.altitudepublishing.com
1-800-957-6888

Extreme care has been taken to ensure that all information presented in
this book is accurate and up to date. Neither the author nor the
publisher can be held responsible for any errors.

Publisher	Stephen Hutchings
Associate Publisher	Kara Turner
Editors	Pat Kozak and Gayl Veinotte

We acknowledge the financial support of the Government
of Canada through the Book Publishing Industry Development
Program (BPIDP) for our publishing activities.

Altitude GreenTree Program
Altitude Publishing will plant twice as many trees as were used
in the manufacturing of this product.

National Library of Canada Cataloguing in Publication Data

Porter, Michelle, 1975-
 Rebel women of the East Coast / Michelle Porter.

(Amazing stories)
ISBN 1-55439-014-1

 1. Women--Atlantic Provinces--Biography. I. Title. II. Series: Amazing
stories (Calgary, Alta.)

FC2006.P67 2005 920.72'09715 C2005-902837-8

Amazing Stories® is a registered trademark of Altitude Publishing Canada Ltd.

Printed and bound in Canada by Friesens
2 4 6 8 9 7 5 3 1

For Lindsay, Dannika, and all
the amazing women in my life

Author's Note

Women's stories are amazing, but the stories captured in this book are exceptional. These are stories of women who refused to accept any limits, of women who stepped out of a common life and into history, of women living out their best moments, when they dared to do what other women — and men — did not do. In writing about these amazing women, I have tried to capture each woman at the peak of her individual story.

Not all of these women were born on the East Coast, but what they did during their time here forever secures each one a place in East Coast history.

Enjoy the journey.

Contents

Prologue

The women arrived alone and covertly. One by one, each woman approached the darkened building and, after scanning the street for any signs of threat, slipped through the door with barely a rustle of her long skirts.

Inside, Gertrude Harding greeted each woman with a nod. This resolute young woman was a long way from her rural New Brunswick home. But two years of living in London had prepared her for this assignment. She was leader of the Bodyguard, an underground sub-unit of the infamous women's militant suffrage group. Gertrude headed the group of women charged with protecting their leader from the brutality of the police.

The only man at the meeting — an expert in martial arts — began demonstrating attacks as weapons were passed around the room. Women swung one unfamiliar object with growing confidence. It was a wooden club — an effective weapon against police or ruffians who tried to break up meetings. A few minutes into the lesson, Gertrude heard a noise from the skylight. She looked up, and what she saw through the glass left her angry — and frightened. She turned suddenly to the other ladies and announced, "Ladies, this meeting is over."

Within moments, every woman had seen the face peering through the skylight and each had guessed what Gertrude had: that the intruder was from Scotland Yard. Clubs were hidden beneath full skirts, hats readjusted and, as casually as possible, the women left the building, each heart beating like a bird's.

Gertrude, the last to leave, was momentarily blinded by the flash of a camera as she stepped out into the night. Her face, as yet unknown to the police, and the faces of all the other women had been captured on film. Alarmed, they broke up into pairs and headed in different directions. Two police officers followed each couple. They intended to discover the name and address of every woman, and to identify the leader. Without its leader, the group would be unable to function.

Gertrude and her walking partner parted quickly. With an officer shadowing her, Gertrude hurried down twisting streets and alleyways. She slipped into several shops; he was waiting when she slipped out. She jumped on a bus; he followed. She jumped off; he was at her heels. Frustrated and angry, Gertrude wheeled around to face the man.

It was time for a confrontation.

Chapter 1
Francoise Marie Jacquelin La Tour

The sun sat high in the sky, but it gave no warmth. It was Easter day, 1645, and the shore of the Saint John River basin echoed with the bellows of armed men and the crack of cannons. This important part of Acadia — part of a French colony on the Atlantic Coast of Canada — was living out its final days.

A man's voice sliced through the air, warning his general she was in danger. Francoise Marie Jacquelin turned; she faced one hardened soldier among the hundreds Charles de Menou, Sieur d'Aulnay, had sent to destroy her. He charged for her, sword raised above his dark hair and dirty bearded face, chest straining against his armour. This single man wore more armour than a dozen of her men wore on their entire bodies.

Francoise willed her tired arms to raise the sword. Two days of almost constant battle had sapped the strength of this petite Acadian woman; the handle felt thick and heavy in her hands. She swung the blade and intercepted his blow. For a moment, the clang of metal clashing on metal filled her ears, and the force of the impact reverberated throughout her body. Her opponent paused in surprise. He had not expected a manly defence. Taking advantage of his hesitation, she stepped to the side, skirts swirling and tangled dark hair flying. She sank her sword into a vulnerable spot under his upraised arms. He gasped, curled around the wound, and fell to the ground.

After pulling her sticky blade from the prone body, she willed her limbs to move and sought another opponent. Evading his weapon, she struck at his stomach, but only ripped his armour. She nimbly sidestepped the next blow, then lunged. This time, her sword sank into his flesh.

When she paused to catch her breath, a bullet whizzed past her head. She spun around to see that it had hit its mark: one of her men screamed and dropped his gun. Francoise snatched it up. Before she could fire the weapon, a cannonball hit the outer wall of her fort, sending jagged pieces of wood flying through the air. Her men, shouting defiance, shot a cannonball back. She would have liked to see how it scattered the invaders, but she couldn't see through the thick smoke.

She called to one of her men to ask if he had any shot. When he nodded, she threw the gun to him. She turned back

to see an enemy soldier dash forward to within three metres of the La Tour cannon. A bullet took out the man tending the cannon. Then the enemy soldier charged at Francoise's comrade, who was nimbly loading shot into the gun Francoise had recovered. In a moment, Francoise's sticky sword found the flesh of the enemy soldier. He fell, cursing, but did not rise again. The man whose life she'd saved looked up briefly, nodded, then finished his work. When he stood, he sent a bullet into one of d'Aulnay's men.

Where one of the enemy's army fell, three more rushed in to take his place. D'Aulnay had several hundred men — not only foot soldiers armed with muskets, swords, and pike points, but also seafaring men, packed into three ships in the bay. Their cannons, which fired six-pound cannonballs, were pointed at Fort La Tour. Francoise La Tour's army counted barely 45 men, a handful of guns, and a few cannons.

Francoise's hopes were fading with the sun's light. As she surveyed her failing army, she wondered if this was to be her last battle against the gentleman who lusted for her husband's fur trade, his growing fort, and, more important than the rest, his claim to the title of governor of Acadia.

With the whistle of each cannonball and the crack of each musket, Francoise wondered what would be left when, or if, her husband returned. Then something happened that returned hope to her heart. D'Aulnay issued an order: retreat. From the back ranks the soldiers repeated the call, until the soldiers in the front stopped their attack and moved back.

Francoise Marie Jacquelin watched the enemy retreat beyond reach of her fort's artillery. The respite was welcome, but she could not understand why d'Aulnay had ordered the retreat. What little ammunition they'd had when the battle began was almost completely spent. Her fort and her army no longer looked like a formidable force to such a large and well-equipped army. Yet they were retreating and the silence and the stillness were as sudden and deafening as the roar of the musketry and the cannons just minutes before.

Francoise lifted her gaze to the waters against the horizon. She almost expected her husband's ship to appear in the distance, leading a small fleet of defenders from Boston. But the horizon was always the same, empty grey waters lapping against a darkening sky. What could he do to forestall the powers that had rallied against him now?

Her husband, Charles La Tour, was not a gentleman by birth. Taken with Acadia when he first stepped on her shores as a boy, hard work had won for him the title of Acadia's governor. His enemy, Charles de Menou, Sieur d'Aulnay, came to Acadia after Fort La Tour was well established. But, as a gentleman with connections to the king's court, he'd felt entitled to more. A man of lower birth could never be his governor. For years, he'd worked behind the scenes to discredit La Tour. It had worked. La Tour's title of governor had first been shared with his enemy — creating two governors of Acadia, ruling over constantly disputed territory — and then was revoked entirely. La Tour and Francoise dared not return

to France for fear of arrest.

D'Aulnay had ordered a ship to anchor in the mouth of the basin to watch their movements. He had planned to capture husband and wife, to deliver them to France before any friend of La Tour's could petition the king to change his position. Despite the close watch, La Tour slipped past his enemy to sail to Boston, seeking supplies and, if possible, help.

Neither Charles nor Francoise had anticipated an open attack from d'Aulnay.

A shout from one of the men on watch had brought her from her room, running in a long dress and light slippers. Three ships had been seen approaching the harbour, loaded with weaponry and soldiers. They were d'Aulnay's ships.

There had been no time for fear. "Prepare the defence," she called. The cannons were dragged into place. What armour there was, was distributed; muskets were loaded and ready; entrances were reinforced. Her son and nursemaid had been sent into the cellar. She became a general. She barked one order after another, and as she had asked, it had been done.

When his men surrounded Francoise's fort, d'Aulnay had stood on the ship's deck. He offered Francoise a way out: she could surrender the fort to him and to the king of France. Francoise refused. Again he offered, and again she refused. When he offered a third and final time, she ordered her men to answer with a volley of cannon shot. She had lost her chance to avoid bloodshed.

Francoise now pulled herself from her reverie and stumbled towards her loyal men. She had wounded to attend to, the dead to count, and the living to motivate.

Those still standing were waiting for new orders. Pale and haggard, the men swayed on their feet, talking little. Francoise approached. In the silence, her young son's frightened cries reached her, as did his nursemaid's whispered words of comfort. She closed her eyes. There was no time for sentimentality. When she opened her eyes again, she was ready. "Someone will keep watch," Francoise said. A soldier by the name of Hans Vandre volunteered. She watched him as he left the battle-weary group, then turned back to the men before her. She spoke about bravery; she asked about the wounded; she talked about strategy; then she ordered the men to rest. Many dropped right where they stood, sleeping amid the carnage, the blood, and the smell of war.

Two surgeons took turns tending the wounded. One slept while the other worked. Moved by the moans and cries of the injured men, Francoise visited each one, whispering what words of comfort she had.

Though her body ached and her eyes drooped with fatigue, she didn't rest. She counted the weapons, distributed the remaining ammunition, and took stock of what was left of the fort. The place she'd called home for four years reeked. Sulphur from the ammunition stung her nostrils; the smell of her own sweat and the blood of the dead left her queasy. The palisade lay in ruins. She picked her way through the

smouldering debris and looked towards the water.

Hope lingered, the hope that her husband would return at the last moment. She prayed that his ship would appear in the distance, carrying reinforcements: cannons, ammunition, and food. Then they would avenge their terrible losses and rebuild their lives.

When her eyes could no longer focus on the glittering sea and her legs would no longer support her, Francoise took a sip of water and chewed a morsel of bread. Finding a sheltered spot amid the ruins of her home, she sank to the ground, tucked her skirts about her ankles, and fell into an exhausted sleep.

It was an hour before sunset when d'Aulnay's men began to advance again. They crept forward in silence, moving in concert. The guard Francoise had left on watch saw them. As they crept into artillery range, he watched. As they approached the crumbled walls of the fort, he watched. But he did not give the alarm. A rallying cry rose up from the invading army and men poured into the fort like water through a sieve. In exchange for his silence, the traitor Hans Vandre would be one of only two men to survive the battle.

The chilling battle cry roused the La Tour men. Pulling themselves to their feet, they grabbed their weapons and followed Francoise into battle. Again they bravely faced the explosions, the bullets, and cannonballs. Amid the clink of swords and the moans of the wounded, they prayed for a miracle.

When d'Aulnay again called for his men to retreat and again called for surrender, Francoise sent the runner back with this message: she would not surrender unless he agreed to spare the lives of each and every one of her men. D'Aulnay agreed to her terms. Francoise ordered them to lay down their arms.

With fear and grief, she watched d'Aulnay approach the ruins of the fort and take it as his own. D'Aulnay's men entered first. They ordered Francoise and her men to stand single file in the middle of the ruins. Only then did d'Aulnay enter the fort of Charles La Tour, the man he'd worked tirelessly to ruin.

In counting the dead, d'Aulnay realized how pitifully small the opposing army had been. And yet they had fought like 500 men. Such losses they had caused him! He was filled with rage — and vengeance.

He stood before his captives. "If I had known how few defenders there were, I would never have agreed to Madame Jacquelin's terms of surrender," he said in a low, tight voice, more threatening than any shout. "You will pay for your obstinacy. I will make an example of you all."

He called to his men. "Ready some rope and a platform for the hangings." Then he turned back to Fort La Tour's defenders. "Which among you will hang the rest in exchange for your life?"

There was a silence. No one moved. Francoise stepped forward. "No one," she said.

"I will not offer again. Which among you will hang the rest in exchange for your life?"

One man stepped forward.

As the sun set into the sea, amid the ruins of Fort La Tour on the banks of the Saint John River, Francoise stood with a rope around her neck. She was forced to watch as her loyal men kicked and struggled against the noose. They died slowly and in agony.

She forced herself to mentally block the scene before her. Instead, she saw the day, four years earlier, when she had first looked upon the rocky shores of the Bay of Fundy from the decks of the ship called *Amity*. She was awed by the towering forests, the imposing walls of the fort that would be her home, the plain Frenchmen, and the half-naked Mi'kmaq men who greeted her: did these speak of adventure or of isolation to a physician's daughter who had grown up in a busy French town? No matter, she was going to choose adventure.

It was adventure that beckoned when the offer of marriage came, not from La Tour himself, who couldn't get away from Acadia, but through his partner. The marriage contract was generous and already signed by La Tour — perhaps La Tour felt he needed to compensate for the isolation of what would be her new home. His partner only needed to convince Francoise to sign her name as well. She did.

At that time, La Tour was the sole governor of all of Acadia, appointed by Louis XIV of France. D'Aulnay had only just appeared on the scene, and the future of the wife of a

governor appeared prosperous and happy. What more could she want?

She tangled with her husband's rival within weeks of arriving in Acadia. La Tour decided to take his new young wife to meet d'Aulnay and his wife, setting sail in late summer. They were rudely rebuffed by d'Aulnay's men in his absence, but met d'Aulnay's returning ship in the bay as they were sailing back home. Angered and embarrassed, it didn't take much for La Tour to become embroiled in a sea-battle with d'Aulnay. Cannonballs and shots were exchanged in the space of a few minutes. One of La Tour's men was killed. In the end, d'Aulnay's better knowledge of the waters in that area won out. La Tour surrendered and all aboard were imprisoned in small cells within the walls of d'Aulnay's fort. They were held until La Tour agreed to sign an official letter requesting the king's intervention in their dispute.

From that moment on, Francoise became her husband's staunchest defender. When he could not go to France to plead his cause before the king, Francoise did. When the king refused her permission to leave France because she would only strengthen her husband's position, she secretly engaged a ship and returned to Acadia.

How could it all have come to this, she wondered, as she watched the men cut down the last body and drag it away. One of d'Aulnay's men took her arm roughly and led her from the gruesome scene.

"Where is my son?" she asked repeatedly. But no one

would tell her. He escorted her to a prison cell, where her lady-in-waiting sat.

"You are alive!" the woman gasped.

Francoise could only nod. She still felt the noose around her neck. When she finally slept, she dreamed that her noose had never been removed, that it continued to tighten around her neck.

Though she was allowed out of her cell accompanied by an escort, she walked to the same place each day. She watched for signs of the Mi'kmaq peoples. Each spring they returned to the area. Loyal to La Tour, they were her one last hope of getting word to her husband. Whether she would ask for his help or tell him it was too dangerous to attempt a rescue, she wasn't certain.

Almost a week after her capture, she did see signs — a canoe gliding through the water, a brown back glinting in the warming sun. She allowed herself to dream of being rescued. The next day, before she left for her walk, she scrawled a letter on a scrap of paper and slipped it into her sleeve. Again she scanned the horizon. But she saw no Mi'kmaq that day.

Another week passed before she saw a Mi'kmaq man on land. He was just outside the ruins of the fort, showing one of d'Aulnay's men a pile of furs. He looked up and saw her. She raised her arm in a signal. He nodded slightly and turned back to the negotiation. Francoise's movement made the guard suspicious, so he dragged her back to her cell. She removed the letter very carefully that night and replaced

it with trembling fingers the next day.

The next day, she asked to walk a different route. Her guard shrugged and agreed. She stood in the sun with her eyes closed until she sensed his attention had drifted. When she opened her eyes, he was watching the labours of some of his friends nearby. Breathless with fear, she knelt and pulled the letter discreetly from her sleeve. She placed it on the ground and piled rocks over it in a particular pattern. As she stood, the guard noticed her movements. Again suspicious, he took her back to her cell and then returned to the place where she had stood in the sun. He soon found the barely concealed letter and took it to d'Aulnay.

That evening, d'Aulnay strode into her cell. With obvious pleasure, he told her she would not be allowed out of her prison again until he sent her back to France to stand trial for treason. She answered with cutting words.

But she was not so brave when he left. She curled into a ball in the corner of the cell and would not move. Her lady-in-waiting could not prevail upon her to take water or food again. For Francoise, it was over. She died a few days later in her prison cell, just a few weeks after the fall of the fort. Her lady-in-waiting later reported she died of despair. Someone else claimed it was poison.

D'Aulnay sent Francoise's son to France, where he lived with a member of Francoise's family. She was buried behind the fort, near the soldiers' graves. Though many attempts have been made and many historians have theories

regarding their whereabouts, her remains have never been found. But the power of Francoise's allure remains, and the story of Canada's first heroine continues to be told again and again.

Chapter 2
Sarah Corning

The Greek city of Smyrna was burning. Fires set by the invading Turks grew into hot, leaping combatants the Greek army and Armenian refugees could not fight. The Turkish soldiers were as relentless as the fingers of fire they sent as their vanguard. The outnumbered Greek army were forced into retreat, no longer defending the city, but trying to escape with their lives. Gunfire and screams rent the air.

By this day in September of 1922, there was little hope for anybody still in the city.

Armenian refugees crowded the narrow streets, push, push, pushing their way to the harbour. To the harbour! They'd faced this enemy before. Driven to Greece from their homeland in the years after World War I, these were

survivors of what would later be recognized as genocide. Nearly a million Armenian lives had been lost when the Turks took revenge on the Armenians for allegedly helping the Russians during World War I. Now the terrified refugees were trapped between the burning city and the Aegean Sea. There were no boats to take them to safety. They scanned the glittering horizon hoping someone, anyone, would come.

A young boy saw it first and called out to his mother. She gripped his hand a little tighter. Not hope, she thought, let's not hope yet — but what is this? Belching smoke and forging a quick path through the sea, an American destroyer approached the harbour. A hush came over the crowd as they watched the ship slow, then stop a short distance from the quay. Was this enemy or friend — or neither? American sailors rowed small groups of people to the quay. One of these was a Canadian nurse, Sarah Corning. With two American colleagues, a nurse and a doctor, she had come to offer what medical treatment could be provided to the Greek and Armenian refugees. The destroyer had come to evacuate Americans from the city.

Sarah stepped on the quay and pulled bags of supplies from the boat. The other nurse began talking with the nearest refugees in the crowd. Within minutes, word passed through the crowd. They were going to set up an emergency medical station right there: send the worst to the front of the crowd.

People shuffled and pushed and called out for attention. Frantic parents begged help for their children: a boy

who had been shot in the face, a girl with a crushed hand, a seriously ill baby.

The medics handed out bandages, dressings, and medication quickly and quietly. They didn't pause, even as Turkish soldiers approached. The Turks were in control of the city now. An officer demanded to know what they were doing.

"We are with the Near East Relief agency," said Sarah Corning, the nurse nearest to the soldiers. "We're treating the wounded. I am a Canadian nurse and the doctor ..."

"You will treat nobody here," the soldier said. "Move on." He barked an order to the other soldiers, and they began to close in. The refugees scattered. The medics packed up the few supplies that made up their very basic medic station. But they would not be so easily dissuaded.

They walked toward the heart of the shattered city, stepping over rubble, broken glass, and bodies, followed by some of the refugees. The dead littered every street and alleyway. One blood-soaked figure tried to move. He cried out in pain and called someone's name. Sarah instinctively moved toward him, but the doctor caught her arm. "A soldier. Over there," he whispered, pointing to a group of heavily armed Turks. So she turned away, but the image of the wounded man stayed with her.

The city had become strangely quiet. Sarah and her companions could see faces behind shattered windows; they could feel eyes on their backs, Greek, Armenian, and Turkish eyes. They hadn't walked far when they found a building in

which they could set up another makeshift clinic. At first it seemed the Turks would tolerate their quiet presence. Turkish soldiers passing by barely glanced at the American and Canadian medics. Somehow word spread quickly, and by the time they'd unpacked and organized their supplies again, refugees had already brought in their sick and wounded, held or comforted by a mother, a brother, a friend, or some stranger filled with pity.

The wounds of one man had been dressed and the wounds of a second were being treated when the shouts of approaching Turkish soldiers spilled into the room. Everyone stilled, except for the nurses and the doctor, who continued their work without pause, whatever fear they may have felt.

The soldiers filled the room. Again Sarah and her companions tried to explain to them that they were with a non-partisan humanitarian relief agency. Again the soldiers demanded that they pack up and leave. This time, they received a warning: "Leave now, or risk your lives, every one of you."

What he meant — that the Turkish soldiers would kill them, that they might be caught in the crossfire, or that they would burn with the city — nobody ever knew. They packed their supplies and again walked into the streets. Despite the misery and suffering Sarah and her companions saw, they were powerless to help.

Sarah, however, would find a way to do much more.

What happened between then and the time Sarah

found her way to an orphanage is lost to history. Remarkably understated in her letters and from the few descriptions of her actions on this day, we cannot know how she made the decision to go to the American-run orphanage located in the city. We cannot know why she found her way there while her American companions did not. Did they make a decision to split up? We will never know.

What we do know is that when Sarah and her team stepped from their second clinic, mayhem broke out. "The city was looted," Sarah wrote in a high-school alumni newsletter years later, "then they began to burn it down."

The real situation was much more dramatic than implied in Sarah's plain words. Flames leapt from building to building. What the Turkish soldiers could not carry away, they destroyed.

Sarah separated from her colleagues. She began to run, not in panic, but with purpose. She planned to find the orphanage and to help if she could. She raced through the maze of streets, hoping and praying the orphanage had not been destroyed. She didn't stop until she came across a group of Armenians. "Where is the orphanage?" she called in her broken Armenian.

"Orphanage!" she cried again in desperation. They barely glanced at her, but gestured toward a nearby street.

She set off again, fearing what she might find. What she found was not one building but several, and she was stunned to find them all intact. What she saw when she went inside

took her breath away.

The children were unharmed. In their fear, they were eerily quiet and still. Her joy must have turned to disbelief when one of the nurses in charge of the orphanage told Sarah about her young charges. There were a few Greek children and a few boys, but most of the orphans were Armenian girls under the age of 12 — almost 5000 of them.

The fires were getting closer. There was no time to think about the impossible task ahead of her. Sarah told the women in charge of the orphanage that there was an American destroyer that could take the girls away from the fighting and the fires. Sarah took the hands of two little girls. She counted out 50 others. "Come with me," she said calmly. Sarah prayed there would be room on the destroyer. They began to walk toward the harbour.

This dangerous walk was one Sarah began many years earlier. It was a walk set in motion in Cheggogin, Nova Scotia, where she first dreamed of becoming a nurse. It was a walk she continued when she travelled to New Hampshire to study nursing while most of the girls she knew were planning weddings and baby showers. It was an unrelenting walk, one which led her to join the American Red Cross in 1914 when World War I began and to subsequently join the Near East Relief, a U.S. charitable foundation established to assist the displaced populations of the Balkans, Asia Minor, and the Middle East after the war ended. Sarah's life would not be the same after that day in 1919 when she boarded a ship

that would take her to the Near East Relief's headquarters in Constantinople (now Istanbul) for the first time. She would not return to Nova Scotia for at least two decades.

When she left for Constantinople, she was a soberly dressed woman in her early forties. With her dark hair tied into a bun, she could easily have been mistaken for one of the missionaries who were returning to the overseas posts they had left during the war. Indeed, these missionaries became her teachers during the voyage. From them, she drew out the histories and stories of the people with whom she would soon be working. She studied the languages of the country and could speak a little by the time she arrived at her post. It was from these missionaries that she learned about much of the horror the Armenian orphans had lived through. And it was with these missionaries that she found her motto and mission: save the children.

After arriving in Constantinople, she travelled to Erivan, the Armenian capital. From there she was sent to nearby refugee camps to care for women and babies. By 1921, she had taken charge of an orphanage in a small village at the foot of Mount Arafat. Sarah loved the children. She loved her work. She'd found her place in the world and loved the little village. She did not intend to leave for some years.

But only a year after she returned to Constantinople to renew her contract, the call came to send help to Smyrna. She answered without hesitation.

Now, as she led the Armenian girls through the carnage

and mayhem in Smyrna, she thought of her own children back in Mount Arafat. Their faces came to her, achingly young and yet so old. Both groups had seen more horror than any child should witness.

"Stay close together," she called to the children. "Hold hands. We'll be all right."

Few of the children believed her; they'd all lost their families to the Turks already. Were their own lives more precious? Turkish soldiers were everywhere, running, shooting, raping, and killing. The flames were as insidious and no more predictable. Chunks of masonry collapsed under the blaze as they passed by. Fire blocked their way through one street, so they turned up another.

It was impossible to avoid the soldiers. Some looked at the group, but none tried to stop Sarah. They were still occupied with skirmishes; Armenian refugee girls were not their concern — yet.

But when the first group reached the quay, Sarah made the plight of Armenian refugee girls the concern of the Americans.

"The orphanage is run by an American nurse," she said, as she delivered the children. The sailors agreed to row the children to the destroyer as they waited for the Americans to evacuate. She turned back to the orphanage, where more children were waiting.

As Sarah retraced her steps, she met more groups of children walking to the quay, led by the workers from the

orphanage. She stopped only long enough to tell them the safest route to the quay and assure them American sailors would be waiting for them.

At the orphanage, Sarah took two more tiny hands into her own and led another group to safety. Sarah and the other women made countless trips through the bloodied streets of Smyrna that day. Incredibly, they got every single child to the waiting ship.

Sarah was never able to explain why the Turkish soldiers let them pass again and again. Divine intervention, she would say, if she said anything at all.

After the Americans boarded and the destroyer had sailed away with its precious cargo of children, flames engulfed the harbour. Rather than burn, many of the refugees still trapped there threw themselves into the sea.

During the short voyage to Constantinople, the children stood on the decks, holding hands. They still did not raise their voices above a whisper. It wasn't until they found themselves on land that they believed themselves truly safe again. They dropped to their knees and thanked God.

The next day Sarah took the children on to Athens, Greece. During the following months she established an orphanage for them and for hundreds of others who had lost their parents and their country through war, famine, and disease. In 1924, she returned to Turkey to work in a residential training school.

Sarah never married. She adopted five of the orphans,

all girls, and raised them in Turkey. Several of these girls also became nurses. She returned to Cheggogin, Nova Scotia, to retire. The exact date of her return is uncertain, but it was before 1952, when she was featured in *Ripley's Believe It Or Not*, not for her bravery or exploits, but because she had been born on the same day in the same town in the same year as another Sarah Corning.

In June 1923, King George II of Greece awarded her the Silver Cross Medal of the Order of the Saviour.

On a hillside near the orphanage, a special photograph was taken in 1923. It is now kept in the archives of Nova Scotia's Yarmouth County Museum. Armenian children are arranged into the words, "II Corinthians: I, 8-11."

That biblical passage reads: "For we would not have you ignorant of our trouble which came to us in Asia, that we were burdened beyond measure, above strength, insomuch that we despaired even of life."

Chapter 3
Portia White

The aroma of yeast filled the small house in Truro, Nova Scotia; the bread dough was ready to be punched down, shaped, and set for second rising. Portia White's mother, Izie, sang while she worked. In a long dress and white apron, she bent over a tub of laundry, hands reddening with the heat of the water her second daughter had boiled and poured. Soapsuds, at first white and plentiful, vanished bit by bit as Izie rubbed the clothes against the washboard; slap, slap, splash, slap. She sang a favourite hymn to keep her arms strong and her hands willing.

She looked up at the bread rising across the room, and her song slipped away. "Portia," she called, "the bread needs setting."

Seven-year-old Portia nodded. She'd been amusing her baby sister, Mildred, the White's sixth child, by pointing through the window to people passing on the snow-covered streets.

Portia carried the bread dough to the table and pressed her fist into the domed brown top. The dough crumpled. She pressed with her other hand, then turned the bowl over, letting the dough fall with a plop onto the floured table. Her small hands, already experienced in the art of bread making, pressed into the dough. Press, fold, press, fold. Slap, slap, splash, slap.

She began to hum the tune her mother had been singing. But she changed her mind and burst into another song, one of her father's favourite classical pieces, one he played often on their gramophone. As the house filled with her rich voice, Portia's hands worked faster. Izie smiled over her work and lifted her voice to join her daughter's. From the adjoining room, the eldest two children lent their voices to the song. The family sang as they waited for darkness to fall that evening in 1917.

Ever since she could remember, Portia had had a recurring dream, a wonderful dream. She would be standing on a stage, parading before an audience, always bowing, the roar of applause filling her ears. Yet there were many reasons this dream should never come true. She was black, she was poor, and she was Canadian. Canadian-trained classical singers, even whites, could not be expected to find success on an international stage.

In Nova Scotia in the early 1900s, a quiet segregation was the rule. Black people lived on the margins of white society. Businesses were free to post "whites only" signs on their entrances. Young black men were encouraged to prepare for work as labourers, young women for domestic service in the homes of white families. Black women were not admitted to nursing programmes. The best they could do was teach, but only in under-funded black schools. And black women were definitely not welcome in the world of opera, however beautiful their voices.

Still, she sang.

The voices of the choir surrounded Portia. Light streamed through the coloured windows of the Cornwallis Street Baptist Church in Halifax. This congregation would be nine-year-old Portia's first audience.

During the week, she'd practised tirelessly, her voice spilling out of the wooden church into the street, giving hurried pedestrians a preview. This year, more people than ever filled the pews of the small church on Sundays. They came to listen to the much-talked-about new preacher, Portia's father, and the choir, which each of Portia's 12 brothers and sisters would eventually join. Portia, new to Halifax and new to the choir, shone with the promise she longed to fulfill.

Portia was the third of 13 children born to Reverend William Andrew White and Izie Dora White. What money they had was already stretched tight as a drum. Food, shoes, coats, schoolbooks: there was never an end to want in Portia's

family. Voice lessons and European training were out of the question.

Still, there was the choir. And when their father began to give sermons over the radio, Portia and her sister would sing gospel songs to a wider radio audience.

On this day, her parents nodded their encouragement as Portia stepped forward to sing her solo. She waited for her cue. When it came her voice rose to meet the piano's melody; it rose and wheeled above the sacred music. The congregation sat perfectly still. A few people closed their eyes to better hear the voice of the reverend's daughter. Portia forgot the faces before her and felt the music in her body. Her heart soared.

This was her playground, the place her sweetest childhood memories would be made. These memories would sustain her through the rough years ahead.

The rocking motion of the train began to lull Portia asleep like a lullaby; her eyes drooped. Rain rat-a-tat-tatted on the window. Her skirt and legs were damp from running through the rain to catch the train back to Halifax. In 1933, she lived in Halifax with her parents, but she taught elementary school in Africville, a black ghetto just outside the city that had been founded by ex-slaves after the War of 1812. Her hands still ached with cold. The single wood stove in her two-room schoolhouse didn't keep anyone warm. This twenty-two-year-old woman would gladly have gone straight home. But she had booked a voice lesson.

Four years earlier, Portia had confided in her father. "I

want to sing," she said. "Not just sometimes, but to live by singing, to sing with the freedom and power that a flier feels in the sky."

Her father had expressed two concerns: that she wanted to become a jazz singer, a kind of music he had no respect for and that he couldn't help her, he couldn't send her to Europe.

But Portia dreamed of becoming a classical singer. She wasn't asking for help. She planned, she told her father, to take a teaching job and pay for her musical studies herself. Later in life, Portia would say, "First you dream, then you put on your walking shoes."

She put on her walking shoes. She went to Dalhousie University in 1929 and then found her first job. She taught at several schools for black students in the Halifax area, including the Nova Scotia Home for Coloured Children, a home for black orphans, opened because other orphanages too often turned away black children.

She continued to sing in the choir. She sang at teas and socials. She entered and won small, local singing contests. Singing still felt like freedom; singing still flooded her body with the same joy she'd felt singing over chores with her mother. But everything else weighed heavily on Portia's soul.

Singing lessons cost $3.50 an hour. As a black teacher in a black school, she made far less than a white teacher, only 20 cents an hour. Each month she brought home $35. With that money she had to pay for her train rides, buy her clothes, and

help out at home a bit when needed. The rest went to pay for her precious time with singing instructor Bertha Cruikshanks at the Halifax Conservatory of Music.

Portia allowed herself to close her eyes and shut out the sounds of the train for a while. She imagined herself on stage, singing to a large audience. Perhaps she was in Paris, or even in warm, sunny Rome. When the train jerked to a stop, she tore herself from her dream and stepped out of the carriage and back into the rain.

The next three years brought little more than heart-break.

A baby, Portia's baby, slept in a small hand-made cradle. Just a few hours old, he could not know what his arrival meant to one black woman from Halifax. His mother watched him sleep. She touched his cheek; he didn't stir. The world is too big for such a small baby, Portia thought.

She tried to sleep, but she was too aware of the time that slipped relentlessly away, without pause. Each moment with her son was numbered. She had already decided she would not raise him herself.

The tired old arguments played themselves out in her thoughts one more time: What kind of life could she offer? Where would she get the money to feed and clothe him? How could she ask a child to face life without a father? How could she pursue her career?

Her cousin, a woman happily married and already settled, would raise him as her own. He would have two

loving parents, instead of one penniless mother. And she would have her life, such as it was — a seemingly endless round of teaching, voice lessons, unpaid bills, and dreams that seemed to unravel at the slightest touch.

The next year, in 1935, Portia entered a singing contest and won the Helen Campbell Kennedy Cup for the first time, for her mezzo-soprano solos. That was something. It was enough to keep her working toward her dream. She didn't know it then, but one day she would win that cup so many times, the judges would just give the trophy to her. But before that, the worst happened.

Izie answered the phone on September 9, 1936, to hear a voice on the other line telling her gently that her husband had died. The rock of the family, the man who had expected his children to give their very best in everything, the father whom Portia had sought to please, was gone.

The day of the funeral, the church was filled with mourners; people waited outside the doors and lined up down the street to pay their respects. At the funeral, Portia sang until tears spilled down her cheeks.

Everything changed after Portia's father died. The family had never had much money, but now Izie had to take in boarders to make ends meet. One of the oldest boys dropped out of university to work. One of the youngest — a 14-year-old — left school to find a job. Portia couldn't justify paying for voice lessons any longer. Every penny she earned was needed at home.

Her father's words came back to her: "There are no barriers between you and your heart's desire. Be a big singer, Portia. Make your people mighty proud."

What would he say now? He had not anticipated this barrier.

The decision of a middle-aged doctor on the other side of the world, however, would offer hope to Portia.

Dr. Ernesto Vinci's train arrived on time. A newspaper rested on top of the only vacant seat. He hesitated. In order to sit down, he would have to pick up the newspaper first. And if he picked it up, he would have to look at it. He had read the paper that morning. Its headline that day in 1938, celebrating Mussolini's talks with Nazi Germany, had been burning into his thoughts all day. If he looked at it again now, he was afraid he would not be able to mask his repugnance. Even a facial expression might be enough to get him in trouble with the police. He stood instead.

All day, he had turned his attention from patient to patient, from complaint to complaint, without commenting on the news. If one of his patients mentioned politics, he changed the subject. He didn't trust his tongue and he didn't know who might inform on him.

When he got home, he wanted to talk to his wife immediately, but they had guests, so he didn't dare say anything. As soon as they left, the couple drew together and discussed their future.

"We must leave," he said. "We must get out of the country."

"Where, Ernesto?"

"America. Canada. Anywhere."

"Your practice, Ernesto. You won't be able to work as a doctor."

"I can teach music," he said quickly, as though it were a relief to speak at last. "I have a fine reputation. I've performed in Italy's best opera house. Everywhere, people will want music. But in Italy, there is no future."

They talked until the slanting rays of morning sunlight chased the shadows away.

By 1939, Portia was singing everywhere she could. She still sang at teas and in the church choir. She sang for the soldiers who began pouring through Halifax on their way to the war in Europe. She sang with a jazz band in a local department store. The stages were small, the pay, when it came, even smaller, but she poured all her passion into each performance. Her audiences grew. And people began to ask questions.

"Why isn't that woman singing on a larger stage?" one woman asked her companion after Portia had performed and the applause had died away.

Her companion knew Portia's story, that the singer had talent but no money to pay for voice lessons or European training. The first woman clucked her tongue. It was then, as she stood in the lingering memory of Portia's rich voice, that

she decided to enlist the help of a group she herself was part of, the Halifax Ladies Musical Club.

The mandate of the Halifax Ladies Musical Club was to nurture the development of music in the city. They sponsored concerts and they invited performers to the city. But the group had never offered anyone what they would offer Portia: a full scholarship to cover the cost of all of Portia's voice lessons at the Halifax Conservatory of Music.

Portia could study the music she loved regularly and without guilt. But Portia needed more. If she was to be a success on the international stage, she needed European training.

Enter Dr. Vinci.

When this talented man left Italy — his home, his medical practice, his life — he found a home in Halifax, Nova Scotia, working as a music teacher at the Halifax Conservatory of Music.

However, he didn't take every student who knocked on his door hoping to benefit from his European operatic experience. He chose his students. His only criteria were talent and potential.

It is said he didn't want to hear Portia's voice. The well-known European baritone singer had to be persuaded to take a few minutes to listen to Portia sing.

Portia was nervous when the proud instructor walked into the room in the conservatory where she waited to sing for him. He greeted Portia politely, but without enthusiasm.

After all, he wasn't expecting much. And Portia did what she always did; she lifted her chin elegantly and sang.

His response to her voice was immediate and unequivocal. "How many Marian Anderson's have you in North America?"

It was a compliment. Marian Anderson was a black American classical singer who, despite widespread racial prejudice, had trained in Europe before moving on to worldwide fame.

He would take her as his student. Many years later, Dr. Vinci would comment that Portia was the most talented pupil he'd worked with in North America.

Portia no longer needed to go to Europe. Europe had come to her.

Dr. Vinci was an exacting teacher. He forced Portia — who herself admitted she needed a push now and then — to work hard. Portia had always sung as a mezzo-soprano. No more under Dr. Vinci, who told her that her voice belonged at a lower pitch. He taught her a new method of singing, the *bel canto* or "beautiful song" method. She learned to control her breath, project her voice, and pace her songs. She learned how to stand correctly — and grandly — and to interpret songs in Spanish, French, and German. She studied the languages and cultures of the songs she practised, in order to sing them with feeling. "She is a genius at feeling," Dr. Vinci once said.

Throughout the career Dr. Vinci would help Portia carve

for herself, the singer and teacher would never lose touch. Portia would eventually move to New York; she would be the first Canadian invited to sing at New York's Town Hall; she would tour South America; she would sing before Queen Elizabeth and Prince Philip; and she would continue to seek her teacher's guidance.

Portia's professional debut came on November 7, 1941, in the Eaton auditorium in Toronto. She had rehearsed this night in her dreams so many times. There, the audiences had filled her with excitement. But on this night in Toronto, the audience filled her with fear.

She was thirty. She had only sung at four large concerts before in her entire life, and all had taken place in the Maritimes. She'd studied with Dr. Vinci for only a year. Most serious classical singers would have studied between ten and fifteen years with an experienced teacher before attempting a debut. It was all happening so fast.

As she prepared to walk on stage, fear threatened to engulf her. Her stomach heaved and her breath quickened. She made a quick decision: she would lie to herself. She took a deep breath and told herself that this was only a dress rehearsal. She told herself that all those seats were empty, that this wasn't the night she'd waited for her whole life.

It worked. She walked across the stage calmly, lifted her chin, and looked above the audience. As the piano accompanist began, her breathing slowed and her mind focused. And

when she sang, she sang in a big empty room, for herself.

It wasn't until she finished singing that she saw the audience. It was the kind of audience that had always appeared in her dreams — they wouldn't stop clapping. They loved her.

That same day, the same night, an agent who arranged concerts for Canadian performers approached her: would she sign a contract? "The time has come, Portia," Dr. Vinci said. She signed the contract.

The school in Africville where she worked as a teacher received a telegram requesting a leave of absence. It was granted.

Other pieces began to fall into place, as well. Dr. Vinci offered to continue singing lessons free of charge as she toured Canada. The city of Halifax and the province of Nova Scotia created the Portia White Fund to cover some of the exorbitant costs of touring. (The fund is still offered today to exceptional vocalists in Nova Scotia.)

There was nothing in her way now. Next stop, Town Hall, New York. After that, the world.

She never returned to that school in Africville.

Chapter 4
Molly Kool

 sharp whistle sliced through the air. A steamship cut slowly through the waters, pressing toward Moncton Wharf. Its captain, a crusty and hardened Norwegian seaman, needed a place to berth before low tide forced him and his cargo back down river. That there were two smaller vessels already docked on the small wharf was no obstacle. He sent another sharp whistle into the air and trundled ahead without pause. The Norwegian's intentions were clear: he would not wait for the next high tide to unload his cargo and complete his business; he would take his place at the wharf by persuasion or by force.

Molly Kool, a 22-year-old woman from Alma, New Brunswick, stood on the deck of a small scow, the *Jean K.* The

71-foot scow was powered by twin 15-horsepower gasoline engines. It could carry up to 70 tonnes of cargo. Her decks were piled with lumber, which Molly, as the scow's mate, would unload as the captain dealt with business ashore. The steamship, loaded with pulpwood, was bigger and heavier than the *Jean K.* The little scow would get the worst of any collision that occurred. When another menacing whistle pierced the air, she turned to face the oncoming steamship, arms crossed and sailor's cap in hand.

The other docked vessel was captained by a man Molly knew from her years sailing the Bay of Fundy. When he began to make hasty preparations to leave, Molly called his name to get his attention.

"What are you doing?" Molly asked when he had turned in her direction.

"Getting out of the way," the captain rejoined before he pulled his line in. "You'd best go, too." With that he got behind the wheel and slowly backed out of the way. His load would wait for the next tide.

But Molly didn't get out of the way. Not because her father wasn't on board, not because she was a minor celebrity at the time — the first North American woman to study and receive her mate's papers — and not because she was a woman who'd stepped into the man's world of sea and salt with ease, either. She remained simply because there was work to do.

In the days before highways and transport trucks,

waterways and ships transported goods to buyers. Molly sailed the Bay of Fundy on her father's scow, carrying gravel, lumber, and other goods between Alma, Saint John, St. Stephen, Grand Manan, Parrsboro, and Yarmouth and up the Saint John and Petitcodiac rivers.

The reason for Molly's determination was simple: the longer it took to deliver her cargo, the longer it would take to pick up her next load and the longer it would take to bring home the money. She hadn't got to where she was by being a pushover.

Captain Gunderson edged his unwieldy steamer forward, muttering obscenities under his breath. When the first vessel moved away, he'd been certain the second would turn tail, giving him access to the dock. But this one — this woman, he determined as he came closer — would take a little more persuasion.

But not much, he decided. She was a woman after all. When his steamship, the *Salamis*, reached hearing distance of the sturdy scow, he puffed out his chest, already the size of a barrel. "Get out of my way," he barked in accented English.

"Nothing doing. I got here first and it's here I'm staying," returned Molly.

The captain turned sharply away. If the woman wouldn't follow orders, then he would frighten her into moving. He turned to his two strongest sailors. "When we get close, jump aboard and cast 'er lines off. Then get 'er out of my way."

A whistle bellowed again, and the steamship closed in

upon Molly and her little scow.

Two sailors jumped aboard Molly's scow. But the scow's mate — described in newspapers at the time as feminine and pretty — met them with a belaying pin clutched in hand. At first, the sight elicited smiles from the two goons. But when Molly swung it at the nearest guy's head and missed by inches, they turned around. It was clear she wouldn't miss if she had to swing a second time. Molly chased the sailors back to their sprawling ship.

Captain Gunderson was furious. He lashed a few choice words across the backs of his sailors. Then he turned to the wheel. When the *Salamis* hit the *Jean K*, the scream of metal splintering the scow carried to the shore. A group of men gathered, wondering silently what would happen.

Still, young Molly refused to leave. As the tide went out, the *Salamis* was forced to move back down river and wait for the tide to change.

The next day the *Moncton Daily Times* ran the headline: "Molly Kool Stands Ground At Moncton Wharf, Routs Seamen with Belaying Pin."

In a romance novel, the story would end with these two in each other's arms, but Molly's life was no romance novel, and she was no trembling heroine. She sued the captain for damages, and when he settled out of court, his anger had certainly not turned to affection. The headline to that story read: "Big Boats Cannot Trample Little Ones."

Molly didn't win all her battles through sheer bravado.

She was not a woman who wavered, on-shore or off. But Molly's biggest battle, the battle she waged with her own self-confidence, would not be won in that manner.

The *Jean K* had been built in Molly's backyard. Her father, a Dutch immigrant, put the scow together when he wasn't ferrying lumber from Alma to the larger ships moored in the Bay of Fundy. The completed scow did not bear Molly's name. Instead, it was christened after the family's oldest, Jean. Jean had been expected to work on the scow alongside her father. But, prone to seasickness, Jean grew to dislike sailing and stopped going to sea. The responsibility fell to the next child in line. That was Molly. It was not a responsibility she welcomed.

Molly wanted to become a nurse. The salt water, the pull of the tides, the danger and close-escapes: none of it was romantic to Molly. That a life on the sea was hard and lonely was a simple, bald fact in the world of a child who had first accompanied her father on his scow when she was five years old.

"I didn't have no soft life," she said in 1991 in an interview with an oral historian. "But I didn't know any different." When pressed further — would she go back and do it all again — she faltered a moment, which is unlike Molly, then stated, "I — I don't think I'd ever want to go through it again, no."

What lured Molly to the sea? Economics. In 1934, when Molly first began to go to sea full-time with her father, money was scarce across North America. The Great Depression had

left its mark; there were few jobs and even fewer roads out of poverty. Molly's family could not pay to send a child to college or university. In fact, Molly's family needed her wage to help make ends meet.

"My father had a small vessel. He needed a seaman and I needed a job," she told that historian in 1991. And when she returned briefly to her hometown to take part in the Alma Celebration Days in 2004, she said crisply, "I had to respond to the circumstances that were there for me."

Molly did much more than simply respond.

When she went to sea in exchange for a regular pay cheque, she found herself more than equal to the male world she had joined. "It was damned hard work," Molly would say years later to a *Telegraph Journal* reporter. But it was work that challenged her mind and body, and that satisfied Molly.

Her father taught her everything he knew — how to master a vessel, how to navigate by the stars, how to read the fast-rising currents, and how to charter. Until an illness forced him ashore, Molly never went to sea without him. Even when he stayed ashore, she consulted him about charts and courses. He was her anchor. It was as if she believed that, on her own, she would lose her way, drifting until she lost her life and her scow on the rocks.

The battle with her self-confidence would not be fought yet, however. First, more practical difficulties would be tossed her way.

The Canadian government passed a law that required

owners of these small scows to have a licence. A provision was made for men — and only men. Experienced seamen could take an oral exam and receive a service certificate. A woman, Molly did not have this option.

Molly's father would not be able to continue as captain indefinitely. She wanted to replace him as captain; she didn't want to work as mate on someone else's scow when her father retired. So Molly found another route. It took her three years. She went to navigation school in Saint John.

Molly attended classes irregularly, whenever the *Jean K* carried a load to the city. The instructor, old Captain Richard Pollock, was more than a little surprised to see a girl studying for her mate's papers. Each day, when he walked into class, he would pat Molly's shoulder and say, "My only girl." And that, Molly said, was all anyone in class or out of class ever said.

It wasn't until she wrote and passed her mate's licence exam in 1937 that newspapers took an interest and Molly's name became known outside the Bay of Fundy.

She needed two years of sea experience before she could take her master's. It was during those two years — in May of 1938 — that Molly's altercation with the Norwegian sea captain caught the public's imagination. So, by the time she entered Yarmouth's Merchant Marine Academy in 1939 to study for her captain's papers, Molly's name had been in newspapers and magazines across North America. Everybody knew about the pretty New Brunswick girl who was trying to get her captain's papers. They knew her name

precisely because no woman in the world had ever done it.

Molly stayed in Yarmouth while she studied. Captain Judson Haines would later tell a newspaper that he had never met a student with "a keener grasp of the subject presented in the courses." In mid-April 1939, he recommended she apply to take the examination. She applied.

However, Molly would later say, they decided that there was no "she" in the Canada Shipping Act, the piece of legislation that regulated the shipping industry. Molly could not take the exam with the other students. But could she still take the exam? Well, they were discussing the issue. They would let her know. Molly's classmates wrote their exams with the local examiner. She waited.

After a few weeks, Molly received word. She could write the exam, but the chief examiner from Halifax would come to Yarmouth to help the local examiner give Molly a different exam. She would sit for the exam alone. Rather than the usual three-hour exam made up of math problems, graphs, and sitings, she would answer oral and written questions for two days. The exam was a pass-or-fail test.

Molly was worried. She was certain they would fail her simply because she was a woman. She knew nobody would question a failure.

Still — incredibly — she showed up for the exam. When the two days were over, the examiner from Halifax offered Molly a ride to Digby, where she took the boat back to Saint John.

On April 19 a telegram reached her in Yarmouth: she had passed. She was jubilant. Immediately, Molly sent a telegram to her sister Jean in Alma. It said: "Call me captain from now on."

She wasn't the first woman sea captain in the world. The first woman had received her papers just two months earlier, in Russia.

Molly's father demoted himself to mate. He watched his second daughter take over the *Jean K* with pride. Captain Molly Kool had proven herself to her father, to New Brunswick, and to the world.

Soon after she received her captain's papers, she was reminded, again, that a woman could pay with her life for the wage she earned on the sea.

The fog was thick. The *Jean K* was running down the Bay of Fundy into Saint John. They'd just loaded the scow with lumber in Point Wolfe. Captain Molly Kool heard the bellow of a steamship's horn. It was the S.S. *Yarmouth*, a large steamship that ferried passengers between Saint John and Boston. It was going out of the harbour while the *Jean K* was heading in. Although Molly heard the horn, she couldn't see the ship through the fog. She decided to continue. Molly's father and brother took the lookout on the deckload as the captain steered the scow to her side of the channel. The steamship's horn bellowed again. And then Molly knew that the steamship was not keeping to its side of the channel, it was coming straight through the middle. It was heading right at the *Jean K*.

The local fishermen who daily fished in these waters could have warned Molly. The steamship so notoriously ignored water right-of-ways that they didn't even begin fishing until after the steamship left.

In the fog that morning, the steamship would never even notice if it hit a smaller vessel. The horn blew louder as the steamship approached. Suddenly Molly could make out the hazy silhouette of the steamship. "Get on the deckload!" Molly's father hollered. She ran for it, but she didn't make it. She was on the cabin when the S.S. *Yarmouth* hit the *Jean K* just ahead of the cabin, on the deckload. The blow knocked Molly and the entire cabin into the frigid waters on the starboard side. Molly was dragged under the boat. Engines running and propellers turning, the *Jean K* passed over the water above Molly. She struggled. When Molly came up, she was on the port side. She'd escaped injury.

This story became famous, not only because of the near-death experience, but because of the angry response Molly gave to the people who tried to help. As soon as she surfaced, she found herself bombarded by flying life rings and life jackets. Molly didn't want to trust her life to plastic and air. So she swam past the life rings to grab hold of two planks of the lumber that had been knocked overboard. With one plank of solid wood beneath each armpit, she dodged and ducked more life jackets and rings. The barrage angered the wet and cold sea captain. "Stop throwing useless things at me!" she ordered gustily.

And that story, too, made history.

The story that didn't make the newspapers is the story of Molly's struggle with herself. Soon after demoting himself to mate, Molly's father became too ill to do much more than rest in his bunk in the wheelhouse. Yet, when it was raining and cold, and grey waters were tossing the *Jean K* like a piece of cork, Molly would walk the short distance between the cabin and her father's resting figure. Though Molly read eddies, whirlpools, rocks, and cloud formations like most people read books, she continually checked her readings and impressions with her father.

When the waters became too rough, she would approach her father's cot again in the dim light. Beneath her raincoat, she would have on several layers of clothing. Her double-knit mitts would be wet and half-frozen from pulling the line back in. "It's rough, Dad," she would say. "Do you want to take the wheel?" He would look at her, stand up, pull on his slicker, and guide the *Jean K* safely through the rough waters.

It would take more than experience, more than captain's papers, for Molly to learn to feel confident handling the *Jean K* in rough waters on her own.

When her father died, Molly no longer walked the few steps between the wheel and his cot for advice. The rough waters, the rocks, the bad weather, positioning, were all her responsibility, but in her mind, she constantly asked him the same questions.

One night, while catching a few hours sleep in the

cabin between loads, she dreamed she was taking the *Jean K* through a very bad channel. A whirlpool threatened to suck the little scow in. Rocks waited to catch the scow if she made a wrong decision. Molly walked that worn path between the cabin and her father's cot. She said, "Dad, do you want to take the wheel?" And he said, "No Molly. Go ahead, you can do it."

Molly believed him.

That dream, Molly said, was what gave her the confidence to do what needed to be done for her entire life.

Molly worked as captain of the *Jean K* for about seven years. In 1944, the scow caught fire and had to be towed to Maine for repairs. Molly had planned to return to the sea, but didn't. "It was nice and warm in the wintertime on shore," she quipped to the *Telegraph Journal* reporter in 1998.

Her brother became captain of the *Jean K* after she left. He lost her at sea off Saint John just before Christmas in 1945.

Chapter 5
Carrie Best

he family Carrie Best's mother worked for employed a chauffeur. He drove her home that day in 1918, a day Carrie talked about for the rest of her life.

"Where's your older brother?" Georgina asked Carrie as she took off her coat and the chauffeur drove away. It was dusk. Working all day in a white woman's house, she couldn't know what was happening in the town of New Glasgow, Nova Scotia, that day. Carrie looked at her father and her younger brother, but no one spoke.

"Why isn't he home?" Georgina's dinner plans — boil the water, cut the potatoes, fry the chicken — were crowded out by the fear in the faces of her family. "James," she said to her husband, "what's wrong?"

"He's at work, mama," Carrie cut in, breathlessly. "He can't get home."

"And why not?" Georgina demanded, looking at her husband again.

James put his hand on his wife's arm. "Two boys, one black boy and one white — had a fight. I don't know what it was about for sure."

"And?"

"There's gangs of white boys roaming around with clubs. They won't let any blacks pass to get home or go to work. They're looking for a black man to hurt."

"Mama," a teenaged Carrie said helplessly, "he can't get home."

Georgina looked at the anxious faces of her family. "You get home okay?" she asked her youngest son. He nodded. She put a hand against Carrie's cheek. She looked into her husband's face. "Well, the lot of you can get your own supper tonight," she said gently. "I'm going into town to bring your brother home."

She buttoned her coat again and left quietly.

Carrie watched her mother through the window until her tall, straight body merged with the growing darkness of the evening. "Carrie, come help with dinner. Your mother and your brother will be hungry when they get home," her father said.

At the corner of East River Road and Marsh Street a crowd waited. White youths hurled insults and threats as

Georgina approached. In no uncertain terms, Georgina was ordered to turn back. The hotel where her son worked was about a block away.

Georgina continued walking, apparently unperturbed. The crowd began to close in around the tall, proud, black woman. She stopped walking; her way was blocked. It was then that Georgina heard someone call her name.

She turned to face a young white man. "Georgina," he repeated. "What are you doing here?" A moment before, he'd been a part of an angry crowd. Now he was uncertain. This was a black woman he knew; she had worked in his house years ago.

"I am going to Norfolk House for my son," Georgina said calmly.

The young man turned back to the crowd. "Move back," he called. "Let her pass. Move back." He shoved and pushed at the crowd of his peers, until there was enough room for Georgina. She passed through and continued to the hotel.

When she found her frightened son at the livery stable at the rear entrance — unharmed — the fear that had gripped Georgina's chest lightened a little. But she only said, "I'm taking you home." She tucked her hand under her son's arm and together they faced the angry white mob, and, with the help of the same young white man, were allowed to pass unharmed.

Over a hot supper, Georgina told her family how she'd passed through a New Glasgow race riot to bring her son safely home.

Relieved, Carrie hung on to every word and peppered her mother with questions. It was a story Carrie would tell again and again for the rest of her life. She would write about it in her autobiography, *That Lonesome Road*. She would credit her mother's stand against an angry mob — and her mother's courage — for her own courage in the face of racism.

And Carrie would need courage.

As an adult looking back, Carrie would wonder how she found her way to self-respect and dignity. Born black in a time when segregation and racism were the rule, she would reflect on how she found the will to start Nova Scotia's first black newspaper, champion human rights, become the voice of black Nova Scotia, a role model for black girls in the province and, among other distinctions and awards, be made an Officer of the Order of Canada.

She would write that the process began when she was four years old, sitting on the steps of her home on Provost Street in New Glasgow, watching the world go by. A local lawyer passed by and winked at young Carrie.

Perhaps there was something condescending in the way this white man winked at this young black girl. Carrie turned her face away from the lawyer, who she knew by name because her mother worked at his home sometimes. She felt the first smouldering of outrage, which would burn hot until she died. It was the same outrage that would cause her to restart the Nova Scotia *Clarion* when she was 89, 36 years after it had ceased publication. But when she was four, she

did what every little girl who adores her mother does: she ran to tell her mother all about it.

Both angry and excited, Carrie was a little breathless when she found her mother cleaning on the top floor of their house. As she recounts in *That Lonesome Road*, the young girl blurted out, "Mama, da' Hennie Game look at me and wink he eye — but I never toined; I let he know I no two-cent dude."

"Two-cent dude" was a derogatory term applied to people of low-esteem, and four-year-old Carrie already knew she didn't belong in that class.

One evening in the early 1940s, Carrie and her son Cal stood in line to pay for a movie ticket at the Roseland Theatre in New Glasgow. Their talk was tense and sparse. They were planning a protest. Mother and son didn't know what the evening might bring.

When they paid for balcony tickets, the only tickets offered to black people, Carrie couldn't help smiling at the ticket seller and thanking him in a loud voice. Her son offered his arm. As she took it, she whispered, "Here we go."

They walked away from the ticket booth casually. Passing by the entrance to the balcony, Carrie led her son to the entrance to the main-floor seats. Only white people watched movies in this section.

White faces turned and gaped as they walked in. Cal looked straight ahead. Carrie smiled. They walked leisurely down the aisle, until they found seats in an empty row near the front. People whispered behind them. They heard words

like "black" and "nigger" and "get out." But they pretended not to hear, talking lightly about the movie they were going to see.

The manager, a balding white man, approached. "This is whites-only seating," he said. "You'll have to leave." When Carrie and Cal refused, he became flustered. He tried to take Carrie's arm, but a look from Cal convinced him to drop it. "I'm calling the police," he said as he left.

Carrie looked at her watch. "The movie should have started," she commented to her son. He didn't reply. The manager returned with two police officers in tow. "You are disturbing the peace," the large one said.

"Why, I can't see how we are disturbing anybody's peace," responded Carrie. "We are waiting for a movie to start."

But within minutes, the police had pulled Carrie and Cal from the seats and arrested them in front of the theatre. "What are we arrested for?" Carried demanded.

"Disturbing the peace," the officer responded. Carrie wanted to retort that she hadn't disturbed the peace. The white movie manager and the white patrons who had insulted her and her son had disturbed the peace. But this was a white police officer, so, for once, she kept her thoughts to herself.

The officers dragged the tall woman and her son away. A half-hour later, they were convicted and fined for their offence. Carrie tried to bring some attention to the incident. This, however, was New Glasgow in the 1940s, and few cared what happened to black people — least of all the newspapers.

Carrie believed in the power of information. She had once said, "You know if you don't have a paper, a means of communication, you are hopeless. Particularly as a minority." And there was a vacuum in her community. Carrie stepped in to fill that vacuum and make the black voice heard. In 1946, she founded *The Clarion*, the first black-owned-and-published Nova Scotia newspaper.

It began as a single sheet news bulletin. Published until 1956 (it was revived briefly as the *Negro Citizen* in 1977), *The Clarion* set in motion what would become a lifelong career in media. (Carrie went on to host a radio show, The Quiet Corner, and write a human rights column for *The Pictou Advocate*.)

Shortly after launching her news bulletin, Carrie would help to bring the incredible story of one Nova Scotian woman to national and even international attention.

Stories of oppression and injustice captured Carrie's imagination. She didn't write traditional news stories. She was not objective. She wrote herself into many of her stories. She was openly biased and passionate.

Many of the ideas she wrote about were not popular. Slavery in Canada was one of these. She loved to refute the long held belief that Canadians did not buy, sell, or own slaves. In a Human Rights column regularly published in *The Pictou Advocate* between 1968 and 1975, she wrote: "Black researchers and historians have learned of slave holders in every town and hamlet from Prince Edward Island to Yarmouth and as the slave's descendent [*sic*] still carries the

mark of the oppressed, so does the master's descendent [*sic*] carry the mark of the oppressed."

Carrie ate at restaurants, observing how differently from the white patrons the black patrons were treated. Then she wrote about it. When a black baby was denied burial in a "white" cemetery, she published the story. When poor black families were charged higher property taxes than wealthier business addresses in order to force the sale of those properties, she investigated tirelessly until the city took her seriously. Then she wrote triumphantly: "The excessive tax amounts have been under investigation and one has been referred to the Nova Scotia Human Rights Commission."

Within a few months of its first edition, Carrie used *The Clarion* to publicize the plight of a beautician from Nova Scotia. Carrie wrote about the Viola Desmond case. She would help make Viola's story — and the Roseland Theatre in New Glasgow — famous.

Viola wasn't from New Glasgow. She taught at a beautician's college and owned a hairdressing parlour in Halifax (she was famous singer Portia White's preferred stylist). She was travelling through New Glasgow on her way to Sydney, Nova Scotia, on business.

It was snowing in New Glasgow on November 8, 1946. Car troubles were not unusual, so she didn't panic when her car began to sputter. There was a gas station just half a block ahead, so she flicked on her turning signal, lurched off the road, and rolled to a stop in the parking lot. She turned her

ignition off and tried to start the car again. It wouldn't start.

When Viola asked, the mechanic at the gas station said he couldn't fix the car until the next day. She would have to stay the night. After she had contacted the people who needed to know where she was, she decided to see a movie. The evening seemed too long for an evening alone in a small and dark hotel room.

Up the street from her hotel was the Roseland Theatre.

The walk to the theatre was chilly, and she was quite cold by the time she reached it and quietly requested a ticket. Her mind was on other things — would her car be fixed the next day? — so she didn't notice that she'd received a ticket for the balcony seats. Unfamiliar with the theatre, she didn't notice the separate entrances either, and she walked into the whites-only section.

A silence fell over the room when she walked in. Looking around at the sea of white faces, many of them openly hostile, she must have paused, she must have known she'd done something wrong. But if she noticed their stares, she didn't show it. She decided to continue walking and find a seat. That's how Viola Desmond made history.

When she found a seat, someone hissed, "What are you doing?" But she ignored the voice.

She couldn't ignore the usher when he approached. "You can't sit here," he said.

"But I bought a ticket," she said.

"No. You people are to sit in the balcony."

Viola looked into the usher's face. She said. "I'll sit here, thank you."

He set off to get the manager. When the manager argued that she'd paid less for the balcony seat, she opened her purse. "I'll pay for the main-floor ticket," she said in a pleasant voice, "how much is it?"

"You can't buy a main-floor ticket," he responded.

Still Viola didn't leave. She repeated her offer to pay the difference in price. But it didn't matter; main-floor seats weren't sold to black patrons. A police officer appeared. He and the manager picked Viola up and dragged her outside. They put her into a taxicab, which drove her to the police station.

There, she was locked up. Her cell mates — male prisoners, every one — watched her with obvious interest. Angry and frightened, she found a seat and folded her hands in her lap. She did not take her gloves off. She refused to look at the men ambling about the cell and talking to each other. The middle-class 32-year-old did not move all night. She had never seen the inside of a prison cell before.

The next day she was charged and tried without counsel. Viola wasn't charged with disturbing the peace. And she wasn't charged with sitting in the whites-only section. She was charged and tried for tax evasion.

The reasoning: since she had paid for a cheaper balcony ticket but insisted on sitting in the more expensive main-floor seat, she was one cent short on tax.

During the brief trial, no one admitted that Viola Desmond was black. No one mentioned that Viola tried to pay for a main-floor ticket. She was convicted, fined $20, and ordered to spend 30 days in jail.

Someone called someone, who called Carrie Best. She jumped on the story. Soon the black community was buzzing. Help was organized for Viola through the Nova Scotia Association for the Advancement of Coloured People. The recently formed group raised the money to pay the fine and the costs of Viola's appeals. Newspapers across Nova Scotia and even the United States picked up the story, bringing attention to the segregation that existed across the country. People began discussing race relations in Canada. That was Viola's victory, nine years before Rosa Parks sat at the front of a bus.

Carrie followed the case to the end. She was there when the Supreme Court of Nova Scotia upheld the decision of the lower court. Among the Supreme Court Judges who rendered this decision was the New Glasgow lawyer who had winked at Carrie when she was only four years old. He didn't wink at her this time.

Of all the challenges a small black-owned newspaper faced, the largest hurdle proved to be advertising. Newspapers are expensive to print and the only way to recover that cost is through advertising. Subscriptions are not enough. While Carrie struggled with her newspaper, few white-owned companies were willing to buy a spot in a black-owned

newspaper. Black-owned businesses were willing of course, but few black-owned businesses could afford to buy the amount of advertising needed to keep a newspaper afloat.

One day, Carrie's search for advertisers took her to a store on Barrington Street in Halifax. The owner, Mr. Manuel Zive, a Jewish merchant, greeted her.

"Hello," Carrie began, "I'm looking for advertising for a new newspaper that is being published out of New Glasgow." She went on show him a copy of her single-sheet newspaper. The middle of the paper had a large picture of Viola Desmond, with the following headline beneath in large letters: TAKES ACTION. "I have something to say about racial understanding," she said simply.

Manuel looked over the paper carefully. He looked up at Carrie and studied her face. "You are just a small voice crying in the wilderness," he said, "but keep crying." He went into his back office, where he sat down and wrote out a cheque for $50.00.

In the 1940s, $50 was quite a lot of money.

Forty-five years later, in a presentation to a royal commission on the wrongful conviction of a native man, Donald Marshall Jr., Carrie would say, "I would give anything if Manny Zive could have been here today, to know that I am still crying in the wilderness, but I am not crying alone anymore."

Chapter 6
Mina Benson Hubbard

Mina Benson Hubbard faced a terrifying decision. Little more than halfway through unknown and unmapped lands in Labrador, little more than halfway through a journey similar to the one that had killed her husband two years earlier, Mina had reached a crisis.

It was mid-August, 1905. A month and a half earlier, on June 27, she had begun the journey in the waters of the Northwest River, accompanied by four guides. They had slipped into the river for the first time with ease, paddling canoes loaded with all the food and supplies intended to keep five people alive through two months of travelling, surveying, and mapping unknown portions of a callous, cold, and unpredictable wilderness. She had planned to cover

more than 927 kilometres in two months.

By August 16, almost 500 kilometres of her journey remained ahead of her. Travel was impossible. The snow and rain that had, mercifully, driven away the mosquitoes and flies also whipped the waters into a frenzy that was impossible to navigate. For almost a week, restless and anxious, at a camp near Lake Cabot they'd waited for the storms to pass, telling stories and watching the skies.

Mina had equipped her expedition with enough food to last until the final week in August, when she planned to leave Labrador several hundred kilometres north at Ungava safely aboard a Hudson's Bay Company supply ship. The ship made the journey once a year. What was she to do if the boat left without them? Winter in cold and desolate Labrador, a long and desperate wait for which she was not supplied? Or turn back before Ungava and attempt a return journey with little or no food before the worst of the Labrador winter set in? Failure had not been in Mina's plans.

But in mid-August, it was failure she faced. It had taken a month and a half to cover a little more than 400 kilometres. How could they travel the remaining 500 kilometres in less than two weeks?

Sitting at camp trying to keep dry after supper, one of her guides — the one who'd accompanied her husband during his fatal trip — said without much confidence, "We will get you there about two days before the ship arrives." And a second guide commiserated, nodding his head as if trying

to convince himself of the truth in his own words, "When we get down below the lakes we can make forty miles a day if the weather is good."

No one knew what lay between where they were and the last lake. No white man — or woman — had travelled there. Perhaps they could make the journey in 10 days. But Mina did not count on it.

Should she tell her guides to turn back now, before the seasons progressed and they stood a better chance of getting out alive? Or should she insist on making an attempt she was almost certain would be fatal?

That night, Mina carpeted her tent with balsam boughs. She found a bunch of hardy flowers still clinging to life beneath an onslaught of cold, driving rain and wet, heavy snow. These she picked and placed at the head of her tent. Still, she could not relax, could not sleep. She stared into the darkness and worried late into the night.

Little more than 24 months earlier, Mina Benson Hubbard would never even have considered such a journey. Wrapped in her husband's enthusiasm, anticipating and discussing every detail of his forthcoming journey across Labrador, it hadn't occurred to her that she *could* complete such a journey. In a rare interview with the New York *World*, just days before her own expedition two years later, she would say, "it had not struck me that I, as a woman, could go to the wilds of Labrador on an expedition similar to that planned by my husband."

Even by January of 1904, when she'd received the abrupt and awful message — "Mr Hubbard died October 18 in the interior of Labrador" — Mina didn't believe a woman was capable of doing what she would attempt. "It is true I had thought of it and wished, time after time, that I were a man, so that I could take up his work," she told the reporter from *World*.

The rest of the world agreed with her. Exploring wasn't a woman's vocation.

In 1903, as her husband made his plans, it never occurred to the 33-year-old nurse from Ontario that she might accompany her husband on his trip. But why not? It was with Mina that he'd discussed every detail of the trip. She'd been party to his every decision, from plotting the course to choosing the supplies and the date of departure.

Mina's husband, Leonidas, was an outdoors man. Assistant editor of the American wilderness magazine *Outing*, Leonidas Hubbard packed his canoe trip through Labrador with a full agenda; he hoped to explore and map two of Labrador's larger rivers, meet with the elusive Naskapi Native peoples, witness the great caribou migration, and use all this as material for adventure and nature stories. He asked a close friend and lawyer, Dillon Wallace, to accompany him. Leonidas and Dillon hired George Elson, a Canadian Scots-Cree from James Bay, as their guide.

Her husband left on July 15, 1903, and never returned. He died of starvation in the Labrador interior, lost in a maze

of lakes and too weak to continue the retreat with the rest of his party. Only George Elson made it out for help, returning in time for Dillon Wallace, but far too late to attempt to rescue Mina's husband. The following winter, George Elson returned to carry Leonidas' body and photographic equipment from the frozen interior.

The failure of Leonidas' expedition became the source of some controversy. Upon his return and recovery, friend and lawyer Dillon Wallace wrote an account of the trip. In this book, Leonidas is portrayed as ill-prepared, ill-equipped, and weak-minded, while Dillon comes through as the hero who survived to tell a tragic story and the unfortunate truth about his friend and expedition leader. This book, coupled with the fact that Dillon refused to release to Mina the maps, field notes, and records her husband had kept throughout the expedition, left Mina with no small antipathy for the man her husband had selected as his companion two years earlier.

She didn't believe Dillon's account. She believed her husband had died because the maps and information he'd relied upon had been incorrect, precisely because no white person had yet travelled the region. Had he the correct information — information available to Mina now — his expedition would have succeeded, she believed.

Mina was not an explorer. She was the sixth of eight children born to an Irish immigrant farming family in the Rice Lake district of Ontario. She taught at a local public school until 1897, when she left for New York to train as a

nurse. She was twenty-seven, unmarried, and taking up a new career in a big, bustling city. It was something not a lot of women would have had the courage to do in a time when women were defined by marriage and motherhood. Not an explorer yet, perhaps, but she already possessed the spirit of one.

While working as an assistant superintendent at an infirmary on Staten Island, she met and nursed the husband she came almost to worship. They spent their honeymoon camping, and in 1902, she accompanied him on a canoe trip in Canada. So she wasn't a complete novice when she "suddenly" decided one winter evening in January of 1905, to complete her husband's work, to prove that with a corrected map, his expedition would not have ended in such tragedy.

Alone at her table, wrapped in grief and helplessness, she sat, longing to be a man so that she might finish her husband's work and exonerate his name. During one media interview, she said: "It did not occur to me I could do anything until that January day, when, as I stood looking out the window, aching with a sense of my own littleness and impotence, suddenly something thrilled through my whole being. I could not tell you what it was ... it came like a sudden illumination of darkness, and it meant, 'Go to Labrador.'"

She kept her plans secret until just before she left in June of 1905. Once the media caught wind of her plans, a furor of nasty speculation appeared in newspapers across the world. Dillon Wallace also planned another Labrador

trip that summer, but much more publicly. He would enter the Labrador wilderness a week after Mina, taking a different route than the one Mina followed and the one he'd followed two years before.

Mina maintained she did not know about Dillon's plans when she began to make her own that inspired day in January. Regardless, she would "race" Dillon across Labrador. In newspapers around the world, Mina was portrayed as jealous, distraught, unbalanced, and spiteful, a woman with a "secret mission" who dared to try to upstage a respected man. At the same time, the press painted Dillon a hero, explorer, and author. His expedition would end with success, without a doubt. Well before Mina's adventures were even over, stories claimed she had failed or given it all up. "Mrs. Hubbard to Give Up Labrador Expedition," the *New York Herald* announced on August 14, when neither Dillon nor Mina had had any contact with civilization for a month and a half.

Newspapers became obsessed with Mina's motivation for attempting this expedition. Again, Mina's public explanation — "to complete my husband's work" — can only provide a piece of the story. Her public explanation was one without pretensions, one that kept her in her place, one that the public was most likely to forgive in a woman. Yet, even if we take that explanation at face value, her reasons changed. As she travelled further and further from the bustle, the society, and the criticism, she became more confident, excited, and

independent. The book she wrote upon her return, *A Woman's Way Through Unknown Labrador*, subtly charts the growth of its main character and writer, Mina. It becomes clear that she was no longer following in her husband's footsteps; she was thrilled to be landing on her own two feet.

Mina Benson Hubbard travelled in a dress. She didn't look like an explorer. She was small and slender and, in every picture published with her book, she looked every bit a straight-backed, gentle lady, even many kilometres from civilization. Perhaps, then, it isn't surprising that people wondered if she could tough it out in the harshest wilderness Canada had to offer.

"At first I didn't think you could do it," said one of the men employed at the Hudson's Bay Company at the Northwest River Post near the head of Lake Melville on the afternoon of June 27, 1905. She had been at the post for two days, having taken a steamship from Halifax to the post at Labrador. "But I have changed my mind," the man, Mr. Cotter, continued earnestly. "You can do it, and without any trouble, too." Moments later, Mina's small party stepped into their canoes and glided away from civilization, leaving a week before Dillon's party would.

Determined to prove her husband had not been ill-equipped on his journey, Mina's two canoes were packed with a list of supplies almost identical to the one her late husband had drafted. Tents, flour, baking powder, chocolate,

salt, aces, knives, fishing nets, rifles, and ammunition — all the essentials for survival, as were the heavy skirts, wool stockings, leather knee-length moccasins, and a rubber automobile shirt. The hot water bottle, air mattress, and feather pillow were for comfort; the white blouse, for Sundays, the day of rest. To complete the work she set out to do — explore and map the Northwest River and the George River — she carried cameras and a sextant.

She'd been making up lists and counting supplies for months. This, the first day of her trip, allowed her to leave all that behind. She paddled with ease, feeling lighter and lighter with each kilometre into the frozen wasteland.

Later, before a large, hot, fire, she wrote in her diary that the day had been unspeakably beautiful: the wide blue sky, the green woods and patches of white snow on the mountains, the shining water which made a rhythmic music as each paddled dipped again and again into the water. They stopped twice to eat something, but paddled late into the night. Now and then, Mina put up her paddle and watched the sky silently. In these hours, the woman from Ontario began to claim Labrador as her own.

Camp and bed at 12:45 a.m. George would give the wake-up call by 3 a.m. They'd covered 35 kilometres of their 927-kilometre journey.

And so they travelled. The waters at first were smooth and silver. But again and again they turned white and swirling. Once, after paddling across a particularly rough portion

of river, a breathtaking combination of white foam and a tossing black mass, George turned to her. "I have seen lots of men who would jump out of the canoe if we tried to take them where you have been just now," he said.

There were two ways to deal with waters too rough to paddle. The guides could use poles to push the canoes through difficult passages. Or, if the rough waters stretched too long, the guides portaged, cutting a trail along the river and carrying the canoes and supplies upriver. The exertion left the men trembling. One of the guides said after their first portage: "In a week, George and I will be hardened up so that there won't be any trembling." They ate bannock for supper, made by the guides with flour, salt, baking powder, and water. George said, "You can throw them around, or sit on them, or jump on them, and they are just as good after you have done it as before."

Mina took pictures, recorded measurements to later produce the area's first accurate and detailed map, checked and re-checked their position, plotted and re-plotted their chosen route, paddled when they were in the water, walked when they portaged, endured the flies and the mosquitoes with stoicism, and wrote in her diary — all the things that explorers did.

But by August 16 it was clear that time was running out. That week they had travelled only 19 kilometres. Blowing snow had turned to rain and back again, making travel impossible. Their little camp was wet, cold, and uncom-

fortable. They stayed near the fire, trying to bolster their flagging spirits.

Two evenings earlier, Mina had been polishing her gun before the fire. The guides had been sharing tales and bragging about exploits when the talk moved to the expected meeting with the Naskapi peoples, an elusive tribe with which few white people had had contact. Mina's part-native guides were afraid of the imminent encounter. "If it were only the Hudson Bay Indians we were coming to, there would be no doubt about the welcome we should get," one remarked quietly.

Around the fire, in the great darkness of the Labrador wilds, Mina began to understand the concerns of her guides for the first time. George tried to lighten the mood and commented on the thorough cleaning Mina was giving her revolver.

"Yes," Mina had said lightly; "I am getting ready for the Naskapi."

"They would not shoot you," George responded, suddenly very serious. "It would be us they would kill if they took the notion. Whatever their conjurer tells them to do, they will do."

"No, they would not kill you, Mrs. Hubbard," another guide, who boasted some traditional knowledge of the Naskapi, agreed. "It would be to keep you at their camp that they would kill us."

There was a tense silence. But Mina responded in an unconcerned manner, with a lightness she no longer felt.

"What do you think I shall be doing while they are killing you? You do not need to suppose that because I will not kill rabbits, or ptarmigan, or caribou, I should have any objection to killing a Naskapi Indian if it were necessary."

So it was that on the night of August 16, Mina faced the very real possibility of failure, the fear of starving to death in Labrador's previously unexplored interior, and a growing apprehension about what would happen when she met with the mysterious Naskapi Native peoples as she intended to do. The balsam boughs and flowers she had placed in her tent did little to ease her worries. But exhaustion crept in bit by bit and finally lulled her into a light sleep, the flap of her tent open to the night air.

Two hours later, she awoke suddenly and with a start. Someone or something was peering into her tent.

Heart racing, but still clumsy with sleep, she fumbled for her revolver. In the darkness, one hand found and wrapped around its comforting cool metal. As she turned to face the intruder, the revolver slipped from her hand. She searched the darkness with her hands until she found it again and picked it up, this time with a grip that would not fumble. She turned again, grogginess gone, to face what had frightened her in the middle of the night.

What she faced would have made her laugh, had her heart not still been jumping about in her chest. Hanging right in the open front of her tent was the moon, big and round against the black night.

In that moment, when fear gave way to hilarity after she had pointed her revolver at the moon, she made her decision. She would go on to Ungava, whatever the consequences might be.

On August 27, Mina Benson Hubbard and her party arrived at the Hudson's Bay Company's Ungava post. The ship was late that year. She would wait two months at the post for the ship, which would not leave until the last week of October. Dillon Wallace's party did not arrive until October 14.

She had completed everything she set out to do. She had correctly and accurately mapped the area, including the important Naskapi and George Rivers. Her subsequent book was published with the only large-scale and accurate map of the area. She had witnessed the great caribou migration. Though greatly reduced, it was a sight few white people would ever see again. She had met with the Naskapi peoples, finding them on the brink of starvation. She had recorded everything on film and in her diaries and reports. And, more than all that, she had found herself equal to the task she had once considered too great for any woman: she had claimed Labrador's unsympathetic beauty as her own.

Chapter 7
Margaret Pictou Labillois

I t started the way so many things do, with two women talking over coffee.

"Margaret," one woman said to the other. "You must run for chief next term."

Margaret Pictou Labillois laughed. But the woman persisted. "People are talking," she said. "They say you are the only one who can beat the chief in this election. And someone must beat him."

Margaret laughed again. Become chief? That was ridiculous. There were two reasons: she was mother to a household of 14 children who needed her time and attention and, well, she was a woman. "I can't run against a man," Margaret said, shaking her head. "It wouldn't be right."

Yet the suggestion weighed on Margaret's mind. Eel

River Bar in 1970 was not the same place it had been when Margaret was a girl, digging clams with her people in the sand bars behind her home.

That is where this story really begins, in the sand bars of Eel River Bar First Nation.

About five kilometres east of Dalhousie, on the northern tip of New Brunswick, the Eel River drains into the Bay of Chaleur. The Mi'kmaq of New Brunswick have lived here for generations. When the ocean waters rise during high tide, salt water gushes up the river, reversing its flow. The land is lush and green, and the people leave their windows open all day to let in the sounds of the flowing water and the moving tides.

Each day, when low tide exposed the grey sand bars along the river, everyone on Eel River Bar First Nation went outside. Mothers, fathers, sisters, brothers, grandfathers, and grandmothers — anybody who wasn't at work or in school — pulled black rubber boots or damp sneakers on their feet, found a shovel and a large tin pail, and dug until the tide came back in.

As soon as the water covered their ankles and sloshed into their boots, girls with braided hair, boys with laughing eyes, and mothers and fathers called greetings and news up and down the river. Everyone would come ashore with a bucket full of clams to sell or to cook. The river was more than a livelihood. It was a way of life.

Among these people lived a girl who could dig clams faster than anyone else. This was Margaret. Even as a woman

in her eighties, she would laugh to think of her quick fingers digging in the grainy wet sand for clams. "Everyone said I knew their address," she recalled.

She also recalled the lesson her mother taught her one day while they were digging clams. That was the day the tide went so far out that the people dug clams for three hours before the waters covered the mud flats again.

Margaret and her siblings took their pails and ran to the mud flats, being careful to stay away from the elders' favourite digging spots. Margaret's mother stayed ashore to build a fire. She would cook the clams to sell by the bucketful.

In the early years, raw clams sold for five cents a pail. Cooked clams sold for $2 a pail. When clams became popular the prices went up: $5 for a pail of raw clams and $7.50 per pail of cooked clams. Today, a bucket of raw clams could sell for $15 a pail.

Cold and pink, Margaret's fingers dug through the speckled sand quicker than a clam burrows when it feels your touch. Dig, swish, clink. The sea breeze pulled strands of hair from her braids. Her sisters chatted companionably as they dug nearby. Dig, swish, clink.

As usual, Margaret filled her bucket much faster than her sisters and brother. She brought her bucket to shore, where her mother was tending the fire. Its heat felt good on her hands. She warmed her hand and watched her sisters dig. Her mother set the clams to cook in a pot over the fire.

After a few minutes, Margaret's mother looked up from

her work. "What are you doing?" she asked in Mi'kmaq. Margaret explained that she was waiting for her sisters to come ashore. Margaret's mother replied with words Margaret would repeat to her children and grandchildren — and to reporters who came asking questions.

"Never sit while your sister is digging," Margaret's mother said. "You help her dig. You help her carry it to shore."

So Margaret returned to the mud flats. She helped her sisters dig. She helped her brother dig. She helped the elders dig. Only then did she come ashore.

This, however, was before the dam; this was when the water was clean and deep. Margaret no longer digs clams. Nobody digs clams on the Eel River Bar First Nation anymore.

The dam changed everything.

Much of the river's water was diverted before it travelled through the reserve. Some water passed, but very little. The clam beds that did not dry up entirely became too polluted to dig. Access to Heron Island — a traditional Mi'kmaq location for fishing, clam digging, and food gathering — became too difficult. The river poured into a large reservoir and then flowed on to satisfy the needs of the growing town nearby and the new paper mill.

The people of Eel River Bar First Nation had lost the ability to provide food for their children. They had lost the income they'd earned from cooking and selling what they'd gathered. The chief — who had never opposed the dam's

construction — announced a compensation deal, an amount Margaret recalled was about $100 per family.

Margaret was in her mid-forties when the dam was built. She, her husband, and her children had dug and sold clams every day. What would their future be without the river, without the clams? "What good is the money?" she asked. "I can spend that in no time. I am concerned for our growing families. They will need some place to live after we've spent our hundred dollars."

Without the fish and the clams, Margaret's husband had to take a job at the mill. For the first time, Margaret was dependent on someone else. It was not a comfortable feeling. So, she worked that much harder. Instead of selling clams, she expanded the small canteen that sat on their land. It wasn't the same as those busy days outside on the sand bars. But they scraped by, making ends meet, while other families on the reserve fell into real poverty.

Perhaps, then, Margaret should have been prepared when members of her community began urging her, the girl who knew where the clams lived, to help change things on the reserve.

"You can work miracles," one person told Margaret. Anyone on the reserve who had a problem came to Margaret for help, and usually left satisfied.

Margaret shook her head, but thoughtfully. "I can't work miracles," she replied. "Anyway," she added, "I have to care for my children." This was certainly a consideration. She had

14 children and a small business, and that lesson her mother taught her when she was a girl haunted her.

Another evening, another friend came over. "The election will come soon," she said. "The chief has won every election for years. You must run this time."

Margaret laughed. "My husband would not like it," she said. What would it be like for a man — one who had briefly been chief himself — to be husband to a chief? She laughed again: it was ridiculous. "Someone else will run," she added.

"But you are the only one who can win," her friend asserted.

After that, Margaret couldn't go outside her house, meet with a friend, say hello to a passing acquaintance, or go to a community gathering without someone urging her to run. "You are like the mother of our people," one said. Yet another pointed out, "When someone needs help, who do they turn to? You." And, they all said, "Only you can beat the chief, Margaret."

Margaret didn't want to run. She had 14 children.

The first person from Eel River Bar First Nation to ever graduate from high school, Margaret had gone on to train as a nurse at Hotel Dieu in Campbellton. She had then joined the Royal Canadian Air Force during the war and was stationed in Rockliff to help map the Alaskan Highway. Her picture in uniform was used to promote the recruitment of women and minorities to the military.

Then she'd married and started a family. Sure, she had

done a few unusual things in her life so far. But she couldn't bring the river back. And — could she repeat it enough times? — she had 14 children. A couple of them were still in diapers.

There was a story she often told when her children gathered around asking, what was it like when you were a child? It was about her grandfather. Yet it was about more than that. It was about a way of life her children would never know.

She would tell her children about the evenings her grandfather would paddle out into the waters behind her house. He would leave beneath a full moon, with the west wind blowing the sail on the birchbark canoe he'd made himself. He travelled light: a shovel and pail, a little black kettle for tea, and spears he'd made with his own two hands. There were 24 kilometres between their home and Heron Island, where he went to fish and gather food for the family. Sometimes he would be gone as long as a week. When the little white sail finally appeared again, bouncing in and out of the waves dangerously, Margaret and her brothers and sisters held their breath. They wondered, "will we ever see our grandfather again?" But then their mother would say, "meet him on shore." The east wind always blew in a lot of waves, and it was up to the children to help their grandfather pull the canoe in quickly, before a wave swamped the little birchbark vessel. Margaret would always pull the canoe with her left hand. With her right hand, she searched the canoe for clams, eels, and berries. Her mother scolded. "Those berries

are for winter jam," she would say sternly.

Heron Island was inaccessible now, because the river water was too shallow to navigate. The river still flowed, but for Margaret's children, it might as well have stopped.

The next time someone suggested she run for chief, Margaret thought about that story and said, "Yes, I think I will."

If she did win, she couldn't change the dam, but she could help to find a way forward for her community. She refused to campaign. It wasn't her way. "The people will make their decision," she thought.

In 1970, the people made their decision. That year Margaret became the first female chief in New Brunswick. The girl who knew where the clams lived didn't believe it when they told her. She just laughed when they told her she was chief. When her family convinced her she had indeed won, she felt bad for her opponent. Being a man, she reasoned, the blow would smart that much more that he'd lost to her, a woman. That didn't last more than a passing moment, however. She had work to do.

Those 14 children she was mother to? Her oldest daughter, Colleen, stepped in. She was in her late teens, but already acted as a second mother. She dropped out of school to help raise her brothers and sisters for the two terms (four years) her mother was chief. Without her daughter's help, Margaret simply could not have accepted the incredible responsibility.

Leading her people through the turbulent changes that

the 1970s brought was a full time job. Her work did not go unnoticed. In 1998, she was made a member of the Order of Canada. The citation noted that "as a result of her enlightened leadership, the people of Eel River have reclaimed lands lost through development, and rediscovered their traditions and language."

When the government wanted to locate a dump near reserve lands, right next to the Bay of Chaleur, Margaret refused to give in. They took the dump elsewhere. A new highway cut their reserve into pieces. Margaret couldn't stop the highway, but she didn't let them take Mi'kmaq land for nothing. She negotiated a land-for-land trade, which added two farms to the reserve, one of which contained ash trees of historic and economic value to her people.

Today, Margaret doesn't talk very much about what she did for her community as chief. She talks about how the work transformed the way she thought about her own culture. It was a group of young people who spurred the transformation.

One day, several teenagers approached the chief, Margaret. They told her that they felt lost. They wanted to understand how their grandfathers and grandmothers lived, but they didn't know how to begin. The old ceremonies were no longer celebrated. The old people spoke Mi'kmaq, while the young people spoke English. There was no pride.

Now, Margaret's first language had not been English. She recalled the apprehension she'd felt on her first day of school. She had learned only a few words of English, yet she

would be punished if she spoke in her own language. The shame she learned at that school as she learned to speak, read, and write in English lingered until that day as chief.

She realized she missed hearing Mi'kmaq. She regretted that she had not taught her children the language. That day, she began to understand how language can bring a people closer to each other and their own culture. If the language survived, the culture would adapt.

After winning two terms, she decided not to run; her oldest daughter had cared for her siblings long enough. But Margaret's work had only just begun.

She went on to revive interest in native arts and crafts. She graduated at the top of her class from a native-language instructors program at Lakehead University in Thunder Bay, Ontario. She then went on to teach Mi'kmaq to elementary school children. She established a family business called *Apitjipeg* (rebirth). Family members run a lobster shop, make and sell jewellery, mitts, and moccasins, operate a restaurant, organize social and cultural events, and collect materials to make traditional crafts, such as snowshoes. In late December 2004, she was still working, making Christmas wreaths to fill orders.

The daughter who quit school so her mother could become chief? She married, raised her own family, then returned to school for her GED (General Education Diploma — the equivalent of a high-school diploma). She went on to learn Mi'kmaq and to attend an instructors program as well.

She teaches Mi'kmaq children how to speak their language in her home after school.

This story ends where it began, with people looking for news in Eel River Bar. One day in the fall of 2004, Margaret's daughter Colleen, dropped in for a visit. She had some news for her mother. The dam, she said, would be coming down. They had only to wait for the results of the government environmental assessment.

But there will be no digging for clams, not yet. It will take years, perhaps decades, for the clam beds to recover and the pollution to clear, if it ever does. But soon, when Margaret looks out her window, she should be able to see the river again, strong and deep as it used to run when she was a girl digging clams faster than anyone else.

Chapter 8
Gertrude Harding

A t six o'clock in the evening, 50 policemen marched into St. Andrews Hall in Glasgow, Scotland. The building was large; organizers had expected a considerable audience to fill the hundreds of seats that spread before a wide wooden stage. They had expected the police, but not in such overwhelming force.

To enter, each woman had passed the quiet but intense inspection of one of the plain-clothes detectives who lingered by the front doors. Each had counted with incredulity the dozen or so uniformed officers who surrounded the building. Once inside, those who had arrived early passed the word to those who arrived later: 50 police officers had occupied the basement, from which there was direct access to the stage. All exits from the stage had been blocked. By 7:30, every seat

in the main hall had been filled.

It was early March, 1914. The women seated in the hall had attended for different reasons. Some came in support, women in layers of ankle-length skirts and stylish hats who'd been marching and protesting for years. Others — groups of scandalized old ladies who sat near the front — attended out of curiosity. Even some male supporters paid the entrance fee and took a seat.

The subject of the talk was one that drew interest and indignation: women's suffrage. And the speaker who had drawn such an anxious and expectant audience — and the ire of the law — was none other than Mrs. Emmeline Pankhurst. She was one of two leaders of the Women's Social and Political Union (WSPU), based in Britain. Although she was scheduled to speak at this fundraising event at 8 p.m., no one knew if she would actually come. If she didn't, everybody would understand. If she did, she would almost certainly be dragged away by the mob of police officers that had gathered with just that purpose in mind.

Mrs. Emmeline Pankhurst was a wanted woman. Her crime: inciting the open destruction of British property in protest over women continuing to be denied the vote. She and hundreds of other protesters who had asked for the right to vote had been arrested for destroying property. Once inside prison, these political prisoners found themselves held as common criminals, in the worst wing of the prison and under restrictive conditions. Demanding that their

crimes be recognized as political, hundreds of imprisoned protesters began to go on hunger strikes. When the brutal practice of force feeding these women almost killed several and became too much for the general public to stomach, the authorities had no option but to release the hunger strikers or bear the responsibility of their deaths. It irked the British authorities that once released due to health reasons, these women escaped their full punishment. That's when "The Cat and Mouse Law" was passed.

This was the law that had snared the aging Emmeline Pankhurst. This law stated that the women arrested for the symbolic destruction of property or for protesting in political buildings could be re-arrested after they had recovered from a hunger strike. Many women were arrested up to a dozen times over the period of a year for a single offence, as was Mrs. Pankhurst.

After her latest release from jail, Mrs. Pankhurst had gone into hiding to recover. Her whereabouts had been a mystery to all except a chosen few. If Mrs. Pankhurst spoke tonight, if she simply appeared, she would be dragged off to prison, her impassioned voice silenced yet again. The hall was buzzing with one question: would she come?

Another complication heightened tensions. Everybody knew that the covert WSPU bodyguard was present. Made up of strong and dedicated women who'd served the WSPU faithfully, the full membership was known by one person only, their leader.

Posted at strategic places throughout the crowd, the women of the bodyguard fidgeted anxiously, waiting for the physical skirmish to begin. They'd slipped into Glasgow that morning on a midnight express train from London, posing as an all-women theatrical group to avoid suspicion. Trained in jujitsu and carrying only an Indian club beneath their skirts as weapons, these women were recruited to protect Mrs. Pankhurst from the brutality of the arresting police. Their leader was a 25-year-old woman from rural New Brunswick, Gertrude Harding.

Gertrude had anticipated the police presence. Barbed wire was strung in front of the speaker's platform, hidden behind strands of garland. Should Mrs. Pankhurst arrive and the police begin to close in, this garland would buy the bodyguard a bit of time. Several bodyguard members sat in a semi-circle around the speaker's table.

Gertrude noted that both exits from the stage — one leading to a balcony and the other leading into the basement — were covered by police officers. And Gertrude guessed that some of the rougher-looking male audience members had actually been hired by the police. The bodyguard would not have an easy job tonight.

As eight o'clock passed, whispers carried to Gertrude's seat on the platform: "The police will arrest her before she gets in," and "She won't come, look at all these police, it's too risky."

Gertrude glanced around the room, visually checking

each member of the bodyguard one more time. Each woman stood in her assigned position, covertly easing her club to the most convenient place for a quick draw. Each knew how to wield her weapon and had done so before.

Gertrude's hand itched to get hold of a club. But, before leaving London, she'd been warned not to do anything that might cause her arrest. The police had been targeting the WSPU's various leaders, raiding their homes and offices and carting them off to jail. Their newspaper, *The Suffragette*, had been driven underground. In response to growing militancy and swelling membership, the government had expanded the Political Branch of the Criminal Investigation Department. They hired burly, working-class men and rushed them through an abridged training session. As leader of the bodyguard, Gertrude's arrest would effectively put an end to the secret society of women protecting Mrs. Pankhurst.

Since her appointment to the bodyguard, Gertrude had been living like a fugitive in London, leaving her apartment as infrequently as possible, avoiding the WSPU offices entirely, communicating by a complex chain of messages, and training with the bodyguard at ever-changing locations. It was vital that the leader remain unarmed, not only to keep out of the way of the police, but also so she could remain by Mrs. Pankhurst, acting as a sort of body shield from the blows of the police truncheons and escorting Mrs. Pankhurst through an altercation, if possible ahead of any arresting officers.

An officer coughed. Gertrude turned — was it a signal of

some sort? But the officer only stamped a foot and glared at the platform impatiently. Even he doesn't think she'll come, Gertrude thought.

As little as two years ago, the thought of voting hadn't crossed the mind of the leader of the WSPU bodyguard.

When Gertrude came to London for the first time in August 1912, she was 23 years old. She had left her parent's farm in the little village of Welsford in New Brunswick just two years ago. In the time she'd lived with her sister in Hawaii, she did not hear the term suffragist once. And, though she had more freedom there than she ever had in her life, she was restless.

She came to London to stay with her brother. He had been asked to keep her out of trouble, to keep her from engaging in "unrespectable" activities, such as getting a job. No one counted on the militant suffragists.

In late August, she took her first ride on one of London's double-decker buses. Seated next to the window, she watched the city unfold before her. The clusters of stone buildings, the bustle of the people, and the traffic were fascinating to a young woman who'd grown up in rural New Brunswick churning butter, making soap, and snow-shoeing to school during winters.

Then she saw something that changed her life.

Some distance ahead of the bus, Gertrude could just make out a group of women walking in single file on the street beside the curb. They carried large white posters.

Gertrude turned to one of her brother's in-law who was seated beside her. "What are these women doing?" she asked.

"They're asking for the right to vote, and these you see are the militants, who do all kinds of things to try to force the government to grant them the vote," the relative explained.

It still didn't quite make sense to Gertrude. She'd never met a woman who wanted to vote. Men voted. Women, well, women just didn't.

As the bus approached the women, she watched the little scene so closely, she could describe it almost perfectly decades later. Something inside her responded. Why don't women vote, she wondered suddenly. From that question it didn't take long to move on to: why shouldn't women vote? And why can't I vote? As the bus took her further and further away from the poster parade, Gertrude felt a growing sense of excitement.

She would do it quietly. She would have to slip out of the house on some pretence or other, but she was determined to find out more about these women and what they had to say.

On a Friday afternoon in early February 1913, two women paid admittance fees to the Royal Botanic Gardens, just outside of London, in Kew. There was nothing unusual about them. Dressed for a slow afternoon admiring rare and exotic flowers, they wore long dresses trimmed with lace collars and hats to keep the breeze and sun from their faces. They smiled as they paid their admission fee. Charming young women, the man who took their money thought. And

hungry too, he added to himself as he glanced at the picnic basket that the woman who wore glasses carried, the one who'd been called Gertrude by her friend. There were only two women, but he could see several sandwiches and a banana covering the top of the basket alone. They're probably meeting some men friends, he decided. Then he turned his attention to the next people in the long line.

Gertrude walked into the gardens, holding the basket with assumed carelessness. Beneath the banana and sandwiches she carried a heavy bolt, larger than her own fist.

The two women said a few words to each other, then parted ways. Still holding the basket against her skirts, Gertrude made her way to the orchid houses. She approached a man wearing a white shirt, a white silk tie, and patent leather boots. He was the gardener.

"These are beautiful flowers," Gertrude said in an American accent. The gardener acknowledged her compliment with cordiality.

"Are they difficult to grow?" she asked, warming to her tourist role.

"Some of the orchids here have been nurtured for years," he began. Without any prodding, he told Gertrude where the rarest and most valuable flowers were kept: houses 14A, 14B, and 14C. "Why, many of these flowers are worth ten pounds each," he said proudly. After extricating herself from the conversation, Gertrude walked about the three houses quietly, memorizing the layout and location of the most

valuable flowers. As dusk approached, Gertrude met up with her partner, Lilian. The two women slipped down a secluded path and settled down for a long stay as the rest of the visitors headed toward the exit.

The wind picked up. A light rain turned into a storm. Cold, grey water poured from the skies, and the wind whipped it against the garden house windows. A stoker made his scheduled rounds at one in the morning. He checked the furnaces in the orchid houses quickly, the sound of the storm in his ears.

As he left, two women emerged from the garden outside the building, shivering. Their skirts, heavy with water, stuck to their legs and dragged at their heels. Gertrude approached a heavy door. The bottom of the door was made of impenetrable wood, but it was the top glass panel she aimed for.

Gertrude raised the long iron bolt she'd hidden in her picnic basket that afternoon above her head. She shattered the glass quickly and knocked out the remaining shards before climbing over the wooden panel and jumping into the house. Moments later, Lilian landed lightly beside her. Gertrude led the way through the darkness.

Before they had turned on their electric pocket lamps, they could smell the flowers — a thick, pungent aroma. Under the light of their small lamps, they both stood a moment, in awe. Before them lay one thousand orchids.

"Well," said Gertrude. She walked to a particularly valuable orchid the gardener had pointed out that afternoon, a

Paphiopedilum villosum. With a sweeping movement, she swung her bolt and sent the pot crashing to the tiled floor. Another crash and a few more valuable orchids lay in pieces on the floor. Lilian chose a rare orchid and swung her bolt.

As she turned to choose another flower, Lilian's bolt hit a pane of glass in the wall of the orchid house. It shattered. Hearing the noise, Gertrude looked up to find her partner standing amid shattered glass. Above her, fixed to an iron pole, was a small sign: "Do not touch the plants."

They stood silently for a moment, listening. But all they could hear were the sounds of the rain and the wind. They smiled at each other. "Why not?" Gertrude asked, and swung her bolt against the glass pane walls that enclosed the orchids' artificial climate.

They moved faster now, smashing pots and panes in a measured tempo. Shoes crunched against broken glass, and wind and beating rain blew the heavy warmth from houses 14A, 14B, and 14C.

Shivering again some time later, Gertrude called to Lilian, "Let's go!"

Lilian nodded and followed Gertrude to the walkway. "The bolts!" she called. Gertrude stopped, her bolt suddenly heavy. They tossed their bolts back into what was left of orchid house 14B.

Moments later, Lilian was crouched in the entrance to the second house. From her pocket she pulled a piece of paper, which she carefully placed in the doorway. It said:

Orchids can be destroyed, but not woman's honour.

There was no more time to waste. It took half an hour to run and walk against wind and rain to the shortest section of the southeastern wall. They scaled the slippery six-foot barrier in minutes. Along Kew Road at the other side, they sat down. It was just after two o'clock in the morning. The stoker would return to the orchid houses in less than an hour's time. Rain beat against their faces.

"I thought I'd be in a nice dry prison cell by now," Gertrude said. Lilian laughed. They moved on, more slowly this time.

Any orchid that had escaped the blow of an iron bolt blackened in the icy wind that night and died.

The following Monday *The Times* headline screamed: "Attack On Kew Orchid House; Supposed Suffragist Raid." The *Daily Mail* reported: "In view of the difficulty in escaping from the Gardens the authorities believe that male supporters of women's suffrage were responsible." The *Daily Telegraph* concurred: "At first it was thought that women had been responsible for the raid, but the official opinion now is that, owing to the difficulties of getting into the Gardens, men must have done the work."

Gertrude's courage in the orchid houses did not go unnoticed. Just a few months later, the WSPU decided to train a bodyguard of women to protect Mrs. Pankhurst from police brutality. Gertrude was asked to organize and lead its activities.

Scotland Yard heard whispers about a new group of armed suffragists and sent women to join as spies. But none passed Gertrude's critical eye. Gertrude selected women who were in good physical shape and who could, at a moment's notice, be ready to do battle with the police anywhere. She selected women whose courage would not fail when faced with a burly, angry police officer. In all, 30 women joined.

In order to keep one step ahead of Scotland Yard, Gertrude had to arrange each new meeting in a different location. Messages were often sent by long and complicated routes to escape detection. But meeting notices were sometimes intercepted by the police.

Gertrude tells how one night, just as a meeting began, she spotted someone watching through a skylight of the building they were meeting in. The meeting ended at once and the women were sent home. However, each woman was followed by a police officer. The police were trying to discover the identity of the leader. Gertrude spent hours trying to shake the man following her, and in the end she did. Later, however, she learned that not all the women were so successful.

Whenever Mrs. Pankhurst spoke, chaotic battles between the bodyguard and the police ensued. Sometimes the bodyguard created such chaos that Mrs. Pankhurst slipped away without arrest. Other times, a member of the bodyguard, dressed in clothing similar to Mrs. Pankhurst's, led the police on a wild goose chase, while the real Mrs. Pankhurst escaped by another route.

In response, the police began sending more and more officers to arrest Mrs. Pankhurst. And they began using more and more brutality in their attempts to get to the leader of the WSPU.

It was for this reason that 50 uniformed police officers occupied the basement of St. Andrews Hall in Glasgow, Scotland, in March of 1914, while another dozen surrounded the building and countless plainclothes officers mixed with the crowd.

One moment, everyone was speculating — would Mrs. Pankhurst come, could she get past the police? The next moment, a tiny figure in grey stood on the stage. Amid wild applause, Mrs. Pankhurst began to speak.

"I have kept my promise, and in spite of His Majesty's government, I am here tonight. Very few people in the audience, very few people in this country, know how much of this nation's money is being spent to silence women. But the wit and ingenuity of women is overcoming the power and money of the British government ... [If] it is justifiable to fight for common ordinary equal justice then women... have greater justification for revolution and rebellion than ever men have had in the whole history of the human race..."

The sound of dozens of approaching police boots stopped Mrs. Pankhurst mid-sentence. The bodyguard readied themselves for action as the head of the first policeman appeared in the doorway. Then something unplanned happened.

A woman stood. She was wearing an elegant black

velvet gown and carried a pistol. Known for protests that pushed the envelope, she was not necessarily supported or encouraged by the WSPU. From her place on the platform she took aim at the officer in the doorway. She pulled the trigger, and in the ensuing explosion, the policeman desperately tried to push the officers back, but they poured past him, wielding their truncheons without mercy. The shot had been blank; they were furious. The bodyguard was ready, wielding their Indian clubs, matching the officers blow for blow.

The audience raised their voices, shouting and calling against the police violence. Elderly ladies, who minutes before had had no use for suffragettes, used their umbrellas as weapons, hammering on the heads of two police officers who were trying to get on the platform. They fought off the old ladies only to be prevented by the barbed wire garland strung across the front of the platform.

Chairs soared through the air. The speaker's table was turned over and smashed. Gertrude stayed close to Mrs. Pankhurst as they tried to escape. Struggling through the crowd, Gertrude turned to face a very large policeman. He lifted his truncheon, ready to crack her skull. She held her breath. But he changed his mind. Later Gertrude would say she would never know why he lowered his truncheon. Instead, he picked her up and tossed her onto a pile of overturned chairs.

With Gertrude out of the way, the police officers grabbed at the tiny Mrs. Pankhurst, simultaneously pulling at her

dress, her waist, her arms, and her feet. A gold chain was torn from her neck; a velvet bag worn around her waist was torn away. Shouting and wielding their truncheons liberally, they pulled Mrs. Pankhurst into the street and into a cab. In a moment, they whisked her away.

The fighting stopped, and the police tried to end the meeting. But the crowd refused to go. Women gave speeches and the crowd roared approval, until a mob — 4000 angry people — marched to the Central Police Station in St. Andrews Square.

The headlines in the newspapers the next day called it "The Battle of Glasgow" and devoted much of the front page to the description of the melee.

That month 200 women joined the WSPU in Scotland.

The bodyguard declared victory. It had taken, after all, 100 constables to arrest one sick, middle-aged woman.

Chapter 9
Shanawdithit

hen meat became scarce in the village, Shanawdithit ate eggs that had been ground into powder the previous fall. When these also became scarce, she, her mother, and her sister stripped bark from the trees and ate the lining.

Weeks earlier, Shanawdithit's father had said goodbye. Everybody in the village had agreed that a journey to the coast carried too many risks, but Shanawdithit's father guessed that food was still plentiful there. He did not believe in the mercy of white people.

The day Shanawdithit watched him leave, she became much older than her 22 years. Already, she'd said goodbye to so many. Her people, the Beothuk people of Newfoundland, were dying. There were no babies in the village and no

pregnant women. Shanawdithit had no husband. There was no man who could become her husband. Only old men and relatives.

Although she prayed to the spirits for her father's safe return, she held little hope for him. How would he hunt? Traditionally, the Beothuk hunted in large groups, building wedge-shaped deer fences 16 kilometres long and driving the deer to a narrow opening where men waited with spears for an easy kill. Her father was alone. He had left without weapons; there was not a single spear in the entire village.

If what each of us seeks from life is a time and place to express ourselves, if what is most important to us is the family and friends with which we share our culture, our customs, and beliefs, then Shanawdithit's future was a short, bleak fall from a steep cliff.

Yet Shanawdithit would find a way to transcend the violence, the fear, and the sorrow that was the death of the Beothuk people of Newfoundland. For six brief weeks, this woman's inner light would flicker, but that flicker would be enough.

Though she didn't know it that winter of 1822–1823, Shanawdithit would see her father one more time. The winter was a hard one. Drift after drift of heavy, cold snow had kept them almost entirely confined to their homes and their fires, hunger gnawing at their bellies. In Newfoundland, most winters are hard. But this was the second winter the Beothuk had been unable to complete their traditional winter migration to

the Newfoundland coast for food.

While overflowing with bounty — mussels, salmon, cod, seal, and auk eggs — the coast was now populated with English trappers and fishermen. Most of these men would shoot Shanawdithit and any of her people on sight.

When it became clear that powdered eggs and tree bark would not sustain the village until spring, Shanawdithit's uncle and cousin began to talk of risking the journey to the coast for food.

Shanawdithit's mother was against the idea. "You cannot trust the English," she said, "they are not like us." Shanawdithit's mother was not yet hungry enough to go. Shanawdithit, her mother, and her sister would instead wait for the return of Shanawdithit's father.

Shanawdithit's uncle and cousin left in March. They packed their few belongings quickly and quietly. There was almost nothing to take, anyway; their former affluence was a memory that only the oldest could bring to mind. In their torn deerskin capotes and ragged sealskin boot-moccasins, they were a ragged, unkempt sight. Shanawdithit stood with the remainder of her people, 10 in all, and watched her uncle and cousin leave.

Years earlier, when Shanawdithit was a child, the entire village would have journeyed to the coast by canoe. Now, however, the tribe no longer owned even a canoe. Her uncle and cousin would walk. When Shanawdithit was born on the shore of a large lake in the interior of Newfoundland, in one

of four remaining Beothuk villages, her people numbered 200. Her own village housed 72 people. Disease, hunger, and English guns had claimed all but 10.

The next three weeks brought nothing. No food, no meat, and no hope. Shanawdithit's father had not returned. Was he dead? They could only assume so. Shanawdithit's mother made a decision. They would walk to the coast. They would follow the trail taken by Shanawdithit's cousin and uncle before them. It was a journey that would test Shanawdithit's courage and resourcefulness.

The snow was still deep and made heavy by the warming season. Weakened by hunger, the women walked with short, slow steps. Shanawdithit's sister suffered frequent coughing spells — she was dying of tuberculosis — and needed to rest frequently. Shanawdithit stayed close, whispering tales of the food they would eat on the coast. Their hunger, the trees, and even the sky seemed to close in around them.

After some days, they found signs of the uncle and cousin who'd travelled before them. At first this was encouraging, it made them feel closer to their missing family and gave them hope for the future.

Shanawdithit saw them first. She had been walking ahead of her sister and mother to make the trail a little easier. At first she didn't understand what she was looking at, only that it filled her with dread. Ahead in the snow, stained red with blood, lay two forms, deerskin capotes askew and moccasins frozen. Shanawdithit ran ahead. As she fell before the

frozen bodies of her uncle and her cousin, she cried out in grief and rage. Her mother and sister's voices joined hers.

This was no place for grief; this was not the time for a burial. Shanawdithit reached for her cousin's capote and covered the exposed breasts. She'd been shot while baring her breasts. It was an ancient custom; women in danger could call upon their special right to protection by baring their breasts. In their eyes, the English became more than killers. They became monsters who would kill women and children without reason or provocation.

Certain the English would be close by, the three women fled in panic. First they ran inland, until weariness slowed their steps and hunger forced them to circle back around to the coast again. There, food was everywhere. But the weakened, thin women could not get at any of it. They carried no hooks; they owned no weapons to pierce the hide of a seal or a straggling deer.

They lived for several weeks on blue mussels, pulling them from the rocks along the ocean shore and on the inner bark they continued to strip from trees. Their beaver mittens were worn out; their fingers were so numb, they could hardly hold the knife to open the shells. They built a draughty hut from driftwood and camped near the windy shore, waiting for they knew not what.

The day before Easter, they left the shore of Badger Bay and walked south along the riverbank. Their hunger had become stronger than their fear of white men. Shanawdithit

and her family decided to give themselves up. They expected to reach a settlement in two or three days.

Within four hours they found a trapper, squatting beside a half-skinned beaver.

It was William Cull, a man whose red beard and reputation for killing Beothuk was well known. Shanawdithit knelt in the snow. Her mother and sister knelt beside her. Too weak to run, they stretched out their arms and waited. The trapper raised the long black barrel of his musket in the direction of the women.

Something checked his musket that day and it wasn't pity or compassion. Some months earlier, the government had promised a reward for the live capture of any Beothuk. It was part of a bizarre attempt to "save" the last of Shanawdithit's people: the government people would befriend the captured Native, then send him or her back to their village with gifts. The reward was £100 for each Beothuk, easily worth several thousand dollars today. Instead of shooting, William jerked the women to their feet and pointed with his gun east toward the sea. He would collect three separate rewards.

It was as Cull's prisoner that Shanawdithit would see her father for the last time.

They had walked for perhaps half a day. Shanawdithit was not relieved. She did not believe that William Cull meant to spare their lives. She, her mother, and her sister were convinced he waited only to kill them later on, in a more terrible manner.

A shout from the nearby woods pulled Shanawdithit from her thoughts. Everyone turned and through the pines they saw a trapper in a red mackinaw running towards the creek. The trapper was chasing a man Shanawdithit recognized with a start as her father. The trapper yelled for William to help. William raised his musket again.

When Shanawdithit's father saw the musket, he stopped. He looked at his wife and two daughters. He looked at the trappers in front of him and to his left. He could hear the yells of the trapper behind him. He had no choice: he ran onto the thin ice of the river.

There was a sudden splash and the figure in ragged deerskin clothing and moccasins disappeared into the ice. The trappers aimed their guns, readying for the man to climb out. But he did not reappear.

William Cull brought the women to St. John's, where they were given a room in a courthouse while he tried to collect his reward. The Beothuk women quickly became a curiosity.

It was here that Shanawdithit would begin to separate herself from her sick mother and sister. Her mother was violent and abusive toward any white person who approached her. The approach of a doctor or a priest sent Shanawdithit's mother into a rage, spitting and screaming; Shanawdithit's sister would not accept medicine from the white doctors, though tuberculosis weakened her more and more each day.

In the weeks after her cousin and uncle's murders

and her father's death, Shanawdithit tried to bridge the gap between herself and the white people. She tried to communicate, using hand signals, gestures, and drawings. She repeatedly drew a perfect deer, beginning with the tip of its tail. Though Shanawdithit's attempts at communication endeared her to the white people around her, nobody was very interested in what she had to say. Not yet.

In the streets of St. John's, peopled stopped to openly stare at the dark-skinned women. Children gathered round, incredulous, reaching out to touch the deerskin shawls the women wore over their English dresses. These are the Beothuk? These thin women?

Again Shanawdithit responded differently than her mother and sister. Her mother and sister shrank even from the children. But Shanawdithit let the children come close. Stealthily, she waited until their small hands almost touched her deerskin capote. The she pounced, calling out in Beothuk and making a pretence of trying to catch the children. They scattered like birds and screamed in unfeigned fear, the stories their parents told more real than the thin women — "if you aren't good, we'll give you to the Beothuk." Shanawdithit, even then, in the knowledge that she was an object of fear, laughed hysterically as the children scattered.

James Wheeler was one of those children. As an adult, he would recall that "their fear seemed to be a matter which greatly pleased her, nor did she seem the least abashed at anything."

By the end of summer, the magistrate of the district, John Peyton, decided to return the women to their people. He left the women alone by an abandoned Beothuk village some distance from the coast with a small supply of food and gifts they were to take to their people along with messages of friendship. But there were no more people.

It didn't take long for their small supply of food to run out. Starving again, Shanawdithit tried to lead her mother and sister to help in Twillingate. But tuberculosis and hunger took the lives of mother and sister within one week of each other. Shanawdithit was not only the last of her family and village. She was the last of her people.

Still, she wanted to live. She found a small flat boat and paddled to Burnt Island, where John Peyton kept a permanent residence.

The last of the Beothuk women lived and worked for the next five years as a servant in John Peyton's household. For five years she lived in anonymity, learning just enough English to communicate with the household. Though she must have longed to share, to talk, to tell the story of her people, there was no one to listen — until William Cormack walked into her life.

A passionate philanthropist, Cormack's interest in the Beothuk came too late to change their fate. The Beothuk Institute he helped to form in 1827 had at first dedicated itself to trying to find a living settlement of the Beothuk people in Newfoundland. But when, after extended expedi-

tions into Newfoundland's interior not one living Beothuk was found, that was given up. Instead, Cormack and the institution focused on uncovering everything that could be learned about the soon-to-be-extinct people. That information, however, he would need to draw from a single woman, one who had little cause to be kind to white people.

It was in Shanawdithit's fifth year as servant to the Peyton household that Cormack came to see the Beothuk woman for the first time.

He'd sent a letter ahead to the Peytons announcing his intention to visit. Another servant, Mrs. Gill, greeted him when he arrived early in the morning. "Nancy? She isn't here," the woman said, wiping her hands on a dirty apron. "But she should be back soon. Sit yourself down."

When he asked where Shanawdithit was Mrs. Gill said simply, "she's in the woods." Then she pressed her lips together firmly.

"The woods?" Cormack pressed.

Mrs. Gill set a cup of tea in front of him. "What do you want with Nancy anyway?"

Cormack explained that he believed Shanawdithit could be better educated in St. John's and that, as the last of her race, she could provide information about her people. Almost nothing was known about the Beothuk culture. "Really," he said, "it is to be regretted that this woman has not been taken care of, nor noticed before, in a manner which the peculiar circumstances would have led us to expect."

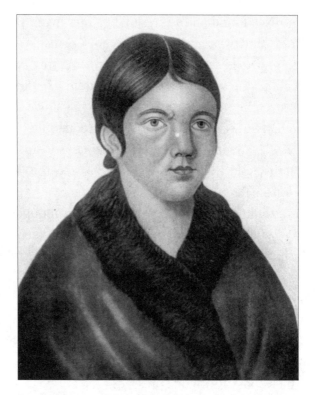

Shanawdithit, the last known Beothuk of Newfoundland

"She is a favourite with the children here, you know," Mrs. Gill said. "They leave their mother to go to her. I can't say that pleases Mrs. Peyton a great deal, but Nancy has a way."

"What work does she do?" asked Cormack.

"Any work she likes. She makes the fires, sweeps, washes the clothes. She doesn't make the bread though, nor sew. She doesn't take any nonsense, either. She's not afraid of the

old lady and can be very pert. When Mrs. Peyton gets cross with the servants, Nance will laugh in her face and say, 'well done Misses, I like to hear you jaw, that right' or 'jawing again Misses.'"

Cormack smiled at this. "Perhaps she will be a good student," he commented. Mrs. Gill added that she was really quick. He sipped his tea quietly a moment. "Why is she in the forest?"

Mrs. Gill busied herself with some wiping up. She glanced again at Cormack and sized him up before she responded. "Well, at times she falls into a melancholy mood. She won't do any work and will just sit and stare. After a day of this, she goes into the forest, as she says, to have a talk with her mother and sister. She comes back singing and laughing or talking aloud to herself. When someone tells her not to be foolish, that they are dead and she can't talk to them, she says 'a yes they here, I see them and talk to them.'"

After that Cormack sat in silence, letting his tea get cold.

By the time Shanawdithit went to St. John's Newfoundland to live with Cormack, they both knew she was dying. Tuberculosis would not spare even her, the last of her race.

She arrived in late September of 1828. For six weeks Cormack and Shanawdithit worked as partners toward a common goal: to preserve the culture of an entire people. Almost everything we know about the Beothuk, Shanawdithit

shared with Cormack in these weeks. Cormack took copious notes and soon became quite excited by the details Shanawdithit told him about Beothuk rituals and religious beliefs. In a letter, he shared his growing excitement regarding the striking similarities between the Beothuk beliefs and rituals and those of the ancient Egyptians. Unfortunately, the majority of those notes were lost after his death.

What remains are 10 of the numerous sketches Shanawdithit drew to show what her limited English could not convey. Five simple scenes depict a series of events that took place in the last years of her life with her people: the killing of two white men; the kidnapping and murder of a Beothuk woman, Demasduit; the murder of Demasduit's husband, the last of the Beothuk chiefs; the return of Demasduit's dead body. The other five sketches depict cultural and religious objects, including a storehouse where venison is dried, a red Indian devil, emblems of mythology, and water baskets.

At the bottom of one page is a sketch of a woman entitled Dancing Woman, or *Thub-wed-gie*. The woman's arms are held aloft in a gesture of joy or praise. Her hair spills carelessly over her shoulders. The fringes on her skirt look as if they would flutter with the smallest step. Beneath her right arm, a fringed flap soars out, defying gravity, as though the woman were turning around and around. But Dancing Woman's feet are firmly rooted to the ground. She does not dance.

Probably drawn to illustrate Beothuk ceremonial dress, the drawing seems to illustrate Shanawdithit herself.

Shanawdithit

When Cormack left Newfoundland in the spring of 1829, Shanawdithit was placed in the care of the attorney general of the colony. Her brief spark faded. Tuberculosis tightened its grip. On June 6, in a hospital bed in St. John's, she left the white man's world she'd entered such a short time ago to join her family in the Beothuk spirit world. She dances there.

Bibliography

Best, Carrie. *That Lonesome Road*. New Glasgow: Clarion, 1977.

Goodall, Lian. *Singing Towards the Future: The Story of Portia White*. Toronto: Napoleon, 2004.

Hubbard, Mina Benson. *A Woman's Way Through Unknown Labrador*. Montreal: McGill-Queen's University Press, 2004. Edited and with an introduction by Sherrill Grace.

MacDonald, M.A. *Fortune & La Tour*. Halifax: Nimbus, 2000.

Wilson, Gretchen. *With All Her Might*. Fredericton: Goose Lane Editions, 1996.

Winter, Keith. *Shananditti: The Last of the Beothuks*. Vancouver: J.J. Douglas, 1975.

Acknowledgments

For these stories I have a lot of people to thank: author Sandra Phinney, from whom I took over this project and who passed to me her preliminary research; the authors of all the books I used for reference; the librarians and researchers at libraries and archives across the Maritimes; the editors and publishers at Altitude for their patience and forbearance with the struggles of a new writer; and of course, my husband, Bojan Furst.

As well as the books listed in the bibliography, the following periodicals were used for reference and quotations: *Kimball Union Alumni Bulletin, Yarmouth Vanguard, Macleans, Chatelaine, Saltscapes,* and *The New Brunswick Reader.*

Photo Credits

Cover: Department of National Defence / Barrack Green Officer's Mess, Saint John, New Brunswick; National Archives of Canada: page 122 (C-038862).

About the Author

Michelle Porter is a part-time freelance writer and journalist and full-time mother living in Saint John, New Brunswick. She graduated from Mount Royal College in Calgary, Alberta with a B.A. in Communications and Journalism. After working with the *Telegraph Journal*, New Brunswick's daily newspaper, she decided to work as a freelancer from an office in a very small apartment. In that office she wrote news and magazine stories, short stories, and radio dramas, and put together the curriculum for a creative non-fiction writing course, which she then taught. She now lives in a much larger apartment with her two-year-old daughter and photographer husband.

AMAZING STORIES™

REBEL WOMEN

Achievements
Beyond the Ordinary

HISTORY/BIOGRAPHY
by Linda Kupecek

REBEL WOMEN
Achievements
Beyond the Ordinary

*"It seems to me there is always somebody to
tell you [you] can't accomplish a thing, and
to discourage you from even attempting it.
If you are going to let other people decide
what you are able to do, I don't think you
will ever do much of anything."*
Katherine Stinson

Many famous women of the west are celebrated
elsewhere. In this book, we meet lesser known
rebels, those who lived with passion, individual-
ity, and courage. These are women who dared to
follow their own path through life; women who
dared to be different.

 True stories. Truly Canadian.

ISBN 1-55153-991-8

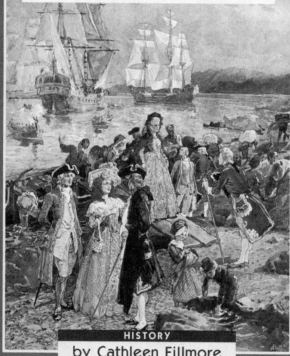

AMAZING STORIES™

THE LIFE OF A LOYALIST

A Tale of Survival in Old Nova Scotia

HISTORY

by Cathleen Fillmore

THE LIFE OF A LOYALIST
A Tale of Survival in Old Nova Scotia

"It was a dangerous time to be loyal to the Crown. The divisive war had pitted neighbour against neighbour and father against son."

The life of young Christiana Margaret Davis, a Loyalist born in upstate New York, was turned upside down by the American Revolution. A time of struggle and strife, she escaped with her family to Nova Scotia, finally landing on Brier Island in 1789. Her remarkable story sheds new light on the plight of Loyalists.

 True stories. Truly Canadian.

ISBN 1-55153-944-6

LUCY MAUD MONTGOMERY
The Incredible Life of the Creator of Anne of Green Gables

"I set my teeth and said, 'I will succeed.' I believed in myself and struggled on alone.... I never told my ambitions and efforts and failures to any one. Down, deep down, under all discouragement and rebuff, I knew I would arrive someday."
L. M. Montgomery

L. M. Montgomery, the creator of Anne of Green Gables and author of more than 20 books, is a household name the world over. *Anne of Green Gables* has been translated into 40 different languages and immortalized on film. The spirited story of orphaned Anne was inspired by the natural beauty of Prince Edward Island.

 True stories. Truly Canadian.

ISBN 1-55153-775-3

LAURA SECORD
The Heroic Adventures
of a Canadian Legend

"Laura plodded forward. The sun began to drop, but the heat continued. Her clothing was soaked with sweat, her feet ached, and her eyes blurred from the heat, the humidity, and fatigue. Still she kept moving."

During the War of 1812, Canadian and British forces battled against the United States with great determination. Many of these soldiers displayed incredible bravery in the face of the enemy. The most legendary act, however, was performed by a civilian woman. This is the story of Laura Secord, a devoted wife and mother who risked life and limb to warn the British military of an impending American attack.

 True stories. Truly Canadian.

ISBN 1-55439-016-8

THE HALIFAX EXPLOSION
Surviving the Blast that Shook a Nation

*"Suddenly, a terrible blast jolted Andrew Cobb
out of his reverie. It felt as though a giant
hand had smacked the train, tipping it up
at a precarious angle before dropping
it back to the tracks with a crash."*

A boat full of explosives heads in to the harbour
as a large cargo ship steams out to sea. What happened
next, on a fateful day in December 1917, is
etched in history. At least 1900 people lost their
lives and 9000 were injured when the largest
man-made explosion ever experienced ripped
through Halifax and nearby Dartmouth. Panic
reigned as the survivors struggled to comprehend
what had happened.

 True stories. Truly Canadian.

ISBN 1-55153-942-X

THE MYSTERY OF THE
OAK ISLAND TREASURE
Two Hundred Years of Hope and Despair

*"If the history of Oak Island showed
anything, it was that searchers were never
so far from the treasure as when they
thought they were on the verge of success."*

In the summer of 1795, a teenager was exploring a tiny island in Nova Scotia's Mahone Bay when he came across a curious depression in the ground. Driven by visions of lost pirate treasure, he later returned to the spot with shovels, pickaxes, and two friends. The trio began to dig, and in so doing launched what would become one of the most famous treasure hunts of all time. For over 200 years, the baffling mysteries of the Oak Island treasure have captured countless imaginations ... they have also been the cause of bitter rivalries, dashed hopes, and tragic deaths.

 True stories. Truly Canadian.

ISBN 1-55153-767-2

AMAZING STORIES™

EMILY CARR

The Incredible Life and Adventures
of a West Coast Artist

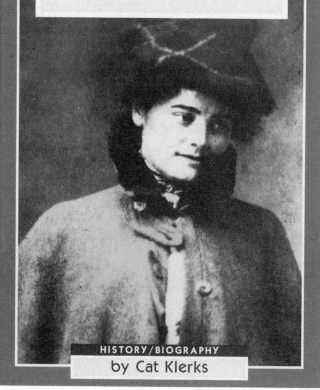

HISTORY/BIOGRAPHY
by Cat Klerks

EMILY CARR
The Incredible Life and Adventures of a West Coast Artist

"On a sketching trip with her friend Edythe Hembroff, Emily made the other woman swear not to peek while she hastily slipped into her nightie. This was odd considering how cheerfully Emily would defy social convention in many other ways. The woman who loved to shock others was quite easily shocked herself."

This is the story of a rebellious girl from BC who travelled the world in pursuit of her calling, only to find her true inspiration in the Canadian landscape she'd left behind. Despite numerous setbacks, she persevered. Today, Emily Carr is a Canadian icon. Her story is a testament to individuality and an inspiration to all.

 True stories. Truly Canadian.

ISBN 1-55153-996-9

OTHER AMAZING STORIES

These titles are available wherever you buy books. If you have trouble finding the book you want, call the Altitude order desk at **1-800-957-6888**, e-mail your request to: **orderdesk@altitudepublishing.com** or visit our Web site **at www.amazingstories.ca**

New AMAZING STORIES titles are published every month.